A
STUDY
OF
Vermeer

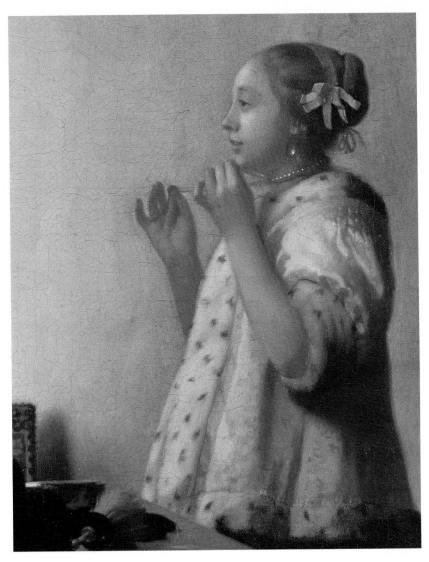

Woman Putting on Pearls (detail of 50)

A
STUDY
OF
Vermeer

EDWARD A. SNOW

UNIVERSITY
OF CALIFORNIA
PRESS
BERKELEY
LOS ANGELES
LONDON

University of California Press
Berkeley and Los Angeles, California

University of California Press, Ltd.
London, England

© 1979 by
The Regents of the University of California

ISBN 0-520-03147-4

Library of Congress Catalog Card Number: 75-32675
Printed in the United States of America

1 2 3 4 5 6 7 8 9

CONTENTS

v

ILLUSTRATIONS

PROLOGUE:
HEAD OF
A YOUNG GIRL

The evening is deep inside me forever.
Many a blond, northern moonrise,
like a muted reflection, will softly
remind me and remind me again and again.
It will be my bride, my alter ego.
An incentive to find myself. I myself
am the moonrise of the south.

<div align="right">PAUL KLEE, The Tunisian Diaries</div>

1. Overleaf: Vermeer: *Head of a Young Girl*.
18¼ × 15¾ in. Mauritshuis, The Hague

IT IS ALWAYS the beauty of this portrait head—its purity, freshness, radiance, sensuality—that is singled out for comment. Vermeer himself, as Gowing notes, provides the metaphor: she is like a pearl.[1] Yet there is a sense in which this response, no matter how inevitable, begs the question of the painting, and evades the claims it makes upon its viewer. For to look at it is to be implicated in a relationship so urgent that to take an instinctive step backward into aesthetic appreciation would seem in this case a defensive measure, an act of betrayal and bad faith. It is *me* at whom she gazes, with real, unguarded human emotions, and with an erotic intensity that demands something just as real and human in return. The relationship may be only with an image, yet it involves all that art is supposed to keep at bay.

Faced with an expression that seems always to have *already* elicited our response, that not only seeks out but appropriates and inhabits our gaze, we can scarcely separate what is visible on the canvas from what happens inside us as we look at it. Indeed, it seems the essence of the image to subvert the distance between seeing and feeling, to deny the whole vocabulary of "objective" and "subjective." And yet few paintings give their viewer such a feeling of being held accountable. If what follows may at times seem arbitrary or impressionistic, I can only say that I have tried to remain open to the painting's address, to keep it continually in view and—a more difficult matter—answer to its look as well.

The experience of *Head of a Young Girl*, for all its sensuousness and singleness of impact, is one of unresolved, almost viscerally enforced contradictions. An intimate mirroring that is also a painful, disturbing estrangement. An all-engulfing (yet patient, gentle) yearning composed equally of desire and renunciation. An accomplished image that evokes with almost the same force as Michelangelo's sculpture the sense of art as a "forcing on [of] the hard beauty that finally coagulates from the endless ceremonials of sadness";[2] yet a fragile apparition at whose edges Macbeth's witches might also be chanting, "Show his eyes, grieve his heart, / Come like shadows, so depart."

The common denominator is a grief—one that goes to the emotional origins of vision itself. Grief seems, if not the subject, then the medium of the painting, the stuff of which it is made. As if to add: "Yet how like a tear that pearl." She may reach out to us as an icon of desire, but grief is the element in which she takes shape. But the painting refuses to be sublimated into tragic or romantic generalization: her eyes sharpen the underlying mood into something more poignant and piercing, and focus it on the artist/viewer with a mixture of reproach and regret that isolates and discloses him.[3] The aesthetic occasion, the acting of looking itself, is haunted here by suggestions of betrayal and violation, and by a certain attendant guilt.

Yet everything that cuts so quickly is at the same time softened, eased, on the threshold of a strangely sensual letting-go. A startled expression that mingles pain, apprehension, and bewilderment (it might almost have been wonder) dissolves, in virtually the same moment it registers, into a wistful, languishing, seductively acceptant look of comprehension and relinquishment. Yet her understanding serves only to tighten the knot of guilt and regret from which it would like to release us. Her eyes accuse yet have compassion, offer consolation yet give irresistible expression to the very desires of which the heart despairs. Their brilliant white reaches out to us in an attempt to hold onto the present instant, even as their heavy lids and limpid pupils reluctantly, voluptuously accept the inevitability of the void into which she already recedes.

The solipsism and specificity of emotional response in which *Head of a Young Girl* involves us seems at odds with the tact and reserve Vermeer's art characteristically requires of its viewer. Consider, for instance, *Woman in Blue Reading a Letter* [2]. Most would agree, I think, that to react by conjuring up the feelings of the woman as she reads the letter, or by providing an anecdotal background to explain the occasion of her reading it, would amount to a violation of what draws us to the painting so intensely. Such an inability to keep one's distance, to let things be, is exactly what has been transcended through the act of creation here. The

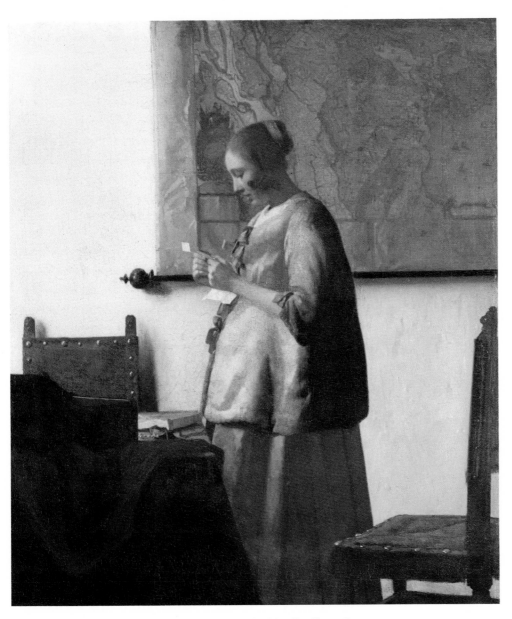

2. Vermeer: *Woman in Blue Reading a Letter*.
18¼ × 15½ in. Rijksmuseum, Amsterdam

painting evokes the possessive, domesticating tendencies of the imagination only in order to overcome them. The letter, the map, the woman's pregnancy, the empty chair, the open box, the unseen window—all are reminders or natural emblems of absence, of the unseen, of other minds, wills, times, and places, of past and future, of birth and perhaps of death—in general, of a world that extends beyond the edges of the frame, and of larger, wider horizons that encompass and impinge upon the scene suspended before our eyes. And yet it is the fullness and self-sufficiency of the present moment that Vermeer insists upon—with such conviction that its capacity to orient and contain is invested with metaphysical value. Such an image is in the realm of being what the map depicted within it is in the world of ordinary existence.[4]

And although it is a moment of human interiority at the heart of the painting that gives it such resonance, it is still the private, ultimately inaccessible nature of the experience that Vermeer contemplates, enclosing it in a world posited over there, out of reach. As a result, the world he opens is impregnated with imaginative life, and seems miraculously close at hand. The eyes, renouncing empathy or understanding, accepting distance and what might seem an impersonal view, unwittingly perform a demiurgical act: they incorporate horizons, bear the space of a world. Her pregnancy becomes, without losing its literal force, an emblem for the richness of inner life that accepting her as other than ourselves bestows upon her. It counters longing and nostalgia with a sense of consummation in a stable present that bears within its own fruitfulness the assurance of a continuous future.[5] But if we attempt to enter into or appropriate the privacy of the moment, to fill the ontological space Vermeer has cleared with psychology or sentiment or anecdotal content or emblematic significance, then we will be reduced to voyeurs peering illicitly into an empty and lifeless world—as Vermeer himself demonstrates to us in the ironically conceived Amsterdam *Love Letter* [3].[6] We would do better to turn our attention, with Gowing,[7] to the saturation of the wall behind the woman, and its more passive, enigmatic sharing in her pregnancy, if we wish to become attuned to the mode of empathy toward which Vermeer's own vision aspires.

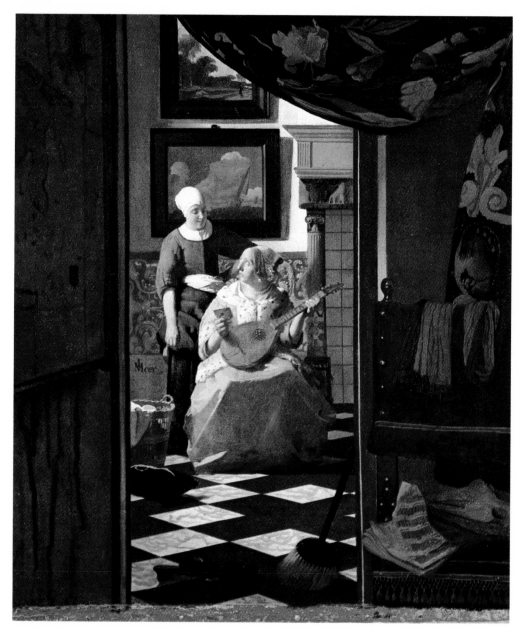

3. Vermeer: *The Love Letter.*
18¼ × 15¾ in. Rijksmuseum, Amsterdam

Yet everything the other Vermeers teach in the way of self-effacement becomes problematical when we return to *Head of a Young Girl*. We seem further than ever from the anecdotal; yet suddenly the most personal responses, drawn from the most private, well-protected corners of the self—even though it may be a self that is strange to us—seem not only relevant to the painting but just what in this instance are not to be evaded. Against the impersonality and timelessness we associate with Vermeer's work, it insists on our involvement in something that is happening, now, in an instantaneous present that reaches urgently toward us instead of taking root in self-contained, imperturbable space. Gone is the measuring, the stepping back, the weight and comfort of context; instead we are confronted with an immediate relation that takes place across an unquantifiable *abyss* of distance.

The painting appears to resist, even despair of, that division into inner and outer, self and other, artist and work, that the other Vermeers, by so radically accepting, so enigmatically transcend. *Woman in Blue Reading a Letter* is like a wish-fulfillment of not just an individual painter but the artistic impulse itself. There consciousness is released from the perspective of the isolated self; it becomes invested with reality, located in being.[8] But the impetus of *Head of a Young Girl* is toward a confrontation rather than a fulfillment of the desires from which it springs. Instead of granting us invisibility, it exposes us to—and in—the light of our own hungering, transgressing, derealizing vision. Art here intensifies rather than eases the sensation of consciousness as hermetically other than itself, opposite itself (in spite of the disruptive otherness of her presence, the look on her face is the expression of how *we* feel as we look at her). The image with which it confronts us is disorientingly immediate, inward, *pre*subjective—she seems to exist inside the eyes as well as at the end of their gaze. Yet the result is to make us only that much more self-conscious of our solitary presence over here, concentrated in an exchange of emotional energy with an image that looks back at us from the other side of a metaphysical divide. Does the desire maintained across this threshold seek to draw her out of the canvas, or to follow her over into the realm into which

she recedes? If it is our life that would make her real, it is her vibrancy of being (as image, as art) that we lack, and long for.

The creator of the *Mona Lisa* was able to boast that "if the painter desires things of beauty to enchant him, he alone is the master to create them." But *Head of a Young Girl* forces us to experience all that is tragic as well as all that is so compelling about such an investment in art's sublimations. The *Mona Lisa* functions as a vantage point from which Leonardo, hidden behind his work, can self-satisfyingly confront his audience with the enigma of his creative powers. But there is no place apart (for either audience, author or creation), no sense of creative arrival, in *Head of a Young Girl*. In no other painting is the power of the image so caught up in a protest against its own inadequacy, against the futility of creation itself. If the quotation from Klee chosen as an epigraph for this essay expresses the sense of hope and inner fullness that enlivens *Head of a Young Girl*, the following passage from Nietzsche just as pointedly captures its passionate despair:

> "For me, the dearest thing would be to love the earth as the moon loves it, and to touch its beauty with the eyes alone"—thus the seduced one seduces itself. . . .
>
> Where is innocence? Where there is will to begetting. And for me, he who wants to create beyond himself has the purest will.
>
> Where is beauty? Where I *have to will* with all my will; where I want to love and perish, that an image may not remain merely an image.
>
> Loving and perishing: these have gone together from eternity. Will to love: that means willing to die, too. Thus I speak to you cowards!
>
> But now your leering wants to be called "contemplation"! And that which lets cowardly eyes touch it shall be christened "beautiful"! Oh, you befoulers of noble names!
>
> But it shall be your curse, you immaculate men, you of pure knowledge, that you will never bring forth, even if you lie broad and pregnant on the horizon.[9]

9

Vermeer, in spite of the images of repose and simple wholeness in which his work consists, is one of the most profoundly dialectical of painters. His greatest and most characteristic paintings, such as *Couple Standing at a Virginal* [37], *A View of Delft* [4], *A Street in Delft* [39], *Woman in Blue Reading a Letter* [2], and *Young Woman at a Window with a Pitcher* [53], generate conviction in an objective order of things permanently achieved, yet balance it against the impression of a world delicately, breathlessly poised, held as if in the palm of a hand. Images of full presence double as evocations of absence and aloneness; openness upon the here and now yields to the impression of a remote, already encapsulated world of the perfect tense. Completeness of being resonates with intimations of death and impending loss; an atmosphere of timelessness evokes thoughts of evanescence, of the momentary, of life passing, and passing by. One has only to study the "poetry of brick and vapour, resistance and penetration"[10] in *A View of Delft*, or the calculated play in *Woman Holding a Balance* [13], *Woman Pouring Milk* [5], *Allegory of the New Testament* [45], and *Artist in His Studio* [41] between things distant and near, horizontal and upright, open and closed, heavy and light, suspended and at rest, to realize that these tensions are not a question of meanings that issue from the paintings in a language perhaps foreign to them, but their very substance, the raw material out of which their world is constructed, and the inner dynamic in terms of which it coheres.

Woman Pouring Milk, for example, is a melody of contrasting physical textures and sensations (the pair of hanging baskets [6] provides the key): rough and smooth, fresh and worn, light and dark, hard and soft, round and angular. The play of natural and manufactured forms and textures (the bread and milk against the various containers and their supports; the wicker basket against the metal one; both baskets against the object on the floor),[11] of things suspended (the baskets and the pitcher suggest contrasting modes) and at rest (the inertia of the things on the table evokes one mood, that of the object on the floor, another), and of things at hand, in hand, and abandoned, out of reach or ken (note the diagonal that descends from the hanging baskets through the pitcher in the woman's hand to the object lying on the floor) implies a concern with the

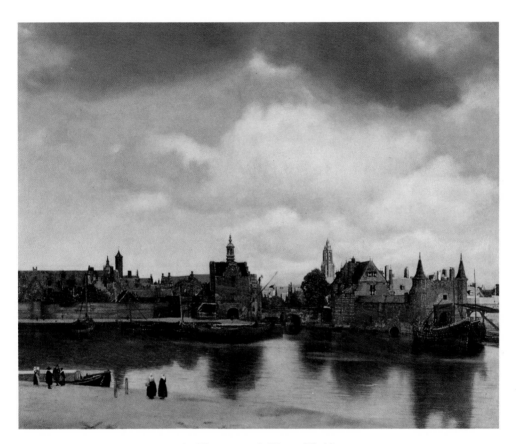

4. Vermeer: *A View of Delft*.
38½ × 46¼ in.
Mauritshuis, The Hague

ontological categories and values imbedded in the sensuous immediacy of the object-world, and with the spiritual life that world acquires through its commerce with the human.

Likewise, the elaborately contrasted images of things open and closed (the metal versus the wicker basket, the pitcher in hand versus the standing jug, the whole versus the broken loaf, conflicting aspects of the object on the floor), full and empty (the basket on the table versus the ones hanging on the wall, the blue overskirt around the woman's waist versus the blue cloth hanging from the table, the bread versus the interior of the jug in the woman's hands), and of interiors disclosed and concealed (the lifted overskirt versus the covered table, the pitcher in hand versus the standing jug, two contrasting aspects of the object on the floor), unknown (the standing jug) and known on trust (the table under the tablecloth, the emptiness of the hanging baskets) indicate an approach to the mysteries of female inwardness that opens—dialectically—upon first principles. This interlocking theme is similarly reinforced by the shorter, crossing diagonal [28] that passes from the self-absorbed expression on the woman's face, down across her tightly laced bodice, through the jug held open in her hands, to the basin in which the milk is being poured, and, finally, to the bread glistening on the table. The condensed, channeled momentum of this diagonal suggests ontological continuity, even generative flow—as if the bread, the milk, and the open vessels were metaphorical extensions of the woman herself and the relationship that is established between her and the viewer.

Bachelard's words might apply to this painting and to *Couple Standing at a Virginal*, *A View of Delft*, and *Artist in His Studio* as well: "On the surface of being, where being *wants* to be both visible and hidden, the movements of opening and closing are so numerous, so frequently inverted, and so charged with hesitation, that we could conclude on the following formula: 'man is half-open being.' "[12] The miracle of Vermeer's art is that while remaining true to the ambiguities of this "half-open" realm, and to the oppositional tensions that are its givens, he is able to bring into being icons of primal goodness and nourishment, and anchor them in a world

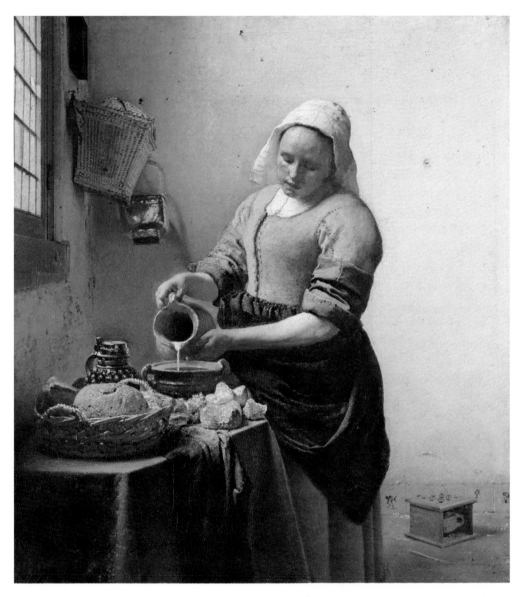

5. Vermeer: *Woman Pouring Milk*.
18 × 16⅛ in. Rijksmuseum, Amsterdam

fully open to the senses, there before the eyes, in both the spatial and the temporal sense.

The oppositional tensions of *Head of a Young Girl*, however, instead of being distributed over a "zone of emotional neutrality,"[13] converge at a point, a threshold of dynamic unrest that insists on the viewer's direct involvement. Instead of perceiving things distant and near, we experience a conflict between emergence and recession. In place of a detached, brooding meditation on the question of life and death, we are given immediate sensations of intensification and easing, quickening and fading, clutching and letting go, labor and deliverance, suddenness and slow time. And if in the other Vermeers we fill the impersonal absence left behind by the artist's effacement from (or disappearance into) his work, here we occupy his place inside the creative process. We can scarcely begin to see *Head of a Young Girl* until we are alive to what must have been at stake for Vermeer in painting it, to the meanings it must have held for him as a personal creation and as a thing apart. With this in mind, let us examine the oppositions that structure the image, and attempt to give sense to the energies they generate.

THE EYES AND THE LIPS. It is possible to look at the mouth and feel it to be "abject and patient,"[14] the parted lips suggesting expiration or acquiescence; yet the brilliant eyes counter this impression by seizing the foreground and holding there, anxious, urgent, and demanding. But at other times these same eyes appear wistful, somnolent, already remote as they recede into the darkness; and then the lips come into the foreground vibrant with anticipation, parted, like those of Hermione's statue ("The very life seems warm upon her lip"), on the threshold of an impossible first breath with which art would emerge—responsively, redemptively—into fully articulate human life. These oscillations ultimately do cohere as a single, inescapably intelligible expression, but they never come to rest, and the conflicts they generate are not resolved: it is extremely difficult, if not impossible, to read either urgency or acquiescence in *both* the eyes and the lips simultaneously.

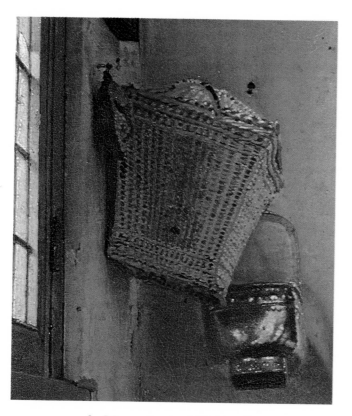

6. *Woman Pouring Milk* (detail)

There may also be a simpler, although more elusive conflict involved in this interplay, having to do with troubled, ambivalent feelings about the erotic motif that is so strong an element of the painting's atmosphere. The appeal of the lips is frankly sensual; their vibrancy is that of the flesh, and their invitation is not to sight but to touch ("Good my lord forbear; / The ruddiness upon her lip is wet; / You'll mar it if you kiss it; stain your own / With oily painting"). But the eyes reach out to consciousness, and to conscience. They posit the charged distance between looks that meet, and at the same time express (it is eyes, not lips, that are the agents of articulation here) all those inward, isolating apprehensions that hold one

15

back from the erotic consummation the lips seem to offer. The impulse to identify the subject of the painting as Vermeer's daughter involves more than biographical curiosity. The erotic immediacy of the painting, its appeal as an image painted on a canvas, and the hermetically private, exclusive affair between the artist and his creation that it both does and does not consummate, have to do with a desire to violate fundamental taboos, to transgress fundamental distances.

THE FACE AND THE HEAD. There is something strangely twin-aspected about this portrait head. Vermeer has managed to impart to the head itself a presence subtly detached from, and even at odds with, the face stamped on its surface. Cover the face and what remains will promise something much closer to a profile than what actually confronts us. A force appears to be striving (from within or beyond the canvas?) to pull the face round toward a frontal view, and flatten it against the surface of the canvas, as if in resistance to the head's own tendency to turn away and recede into background shadows.[15] The head withdraws from us like the dark side of the moon: remote, reticent, and impassive, mysterious and exotic yet solid and impenetrable, calmly indifferent to human preoccupations with personality, expression, and inwardness.

The face, on the contrary, withholds nothing. It lies fully exposed on the surface of the canvas, despite the logic of the three-quarter view[16]—open, vulnerable, incapable of secrecy or evasion, possessed by a candidness that is imposed, not chosen. She *is* her expression, and not a private, inner self dwelling behind it. (In this, as in so many other respects, the *Mona Lisa* is her opposite.) And this expression is entirely, unreservedly a response to the presence of the artist/viewer: the face might almost be imprinted on the head from without by the light that seems to come—uniquely among Vermeer's paintings—from our side of the canvas, charged with the anxious hunger for expression and relatedness that originates there.[17] Between this expressive immediacy determined by the facing presence of another, and the aloof, monumental impersonality of the head that bears it, there seems little room for the securely inhabited, self-possessed interiority that is time and again the subject of Vermeer's work.[18]

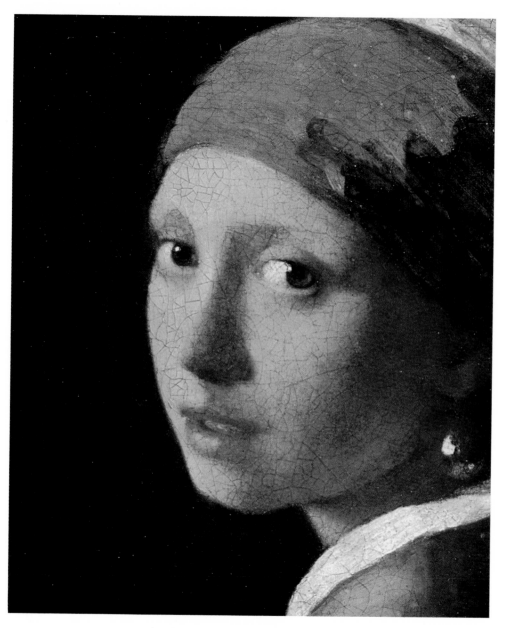

7. *Head of a Young Girl* (detail of 1)

THE TWO PARTS OF THE TURBAN. The turban, like so many
of the inanimate objects in Vermeer's paintings, gathers up and displaces
certain half-sensed feelings and significances that hover about the human
content at the heart of the work. Its tightly knotted portion is wound in
tense repetitions in upon itself—as if to define, contain, defend, hold
tightly to the "pearl-like" integrity of the head. The pendant, however, lies
outside the compulsion to conserve and repeat: serving no purpose, sig-
nifying nothing, it falls, once and for all, without resistance, holding
nothing back, blossoming in the element of gravity—yet still suspended
from the knot from which it issues. This polarity within the turban is itself
unstable: for there is a stiffness about the pendant that undermines the
sense of release and self-abandonment evoked by its fall, while the knot
itself evokes an unknotlike sensation of repose, softly folded in upon itself
as it is in lotus-like contentment. And the pendant falls not straight down
but slightly forward and to the right, subtly in tension with the vertical to
which it appears so voluptuously given over.

The resulting dynamic of the turban both counterpoints and com-
plicates the stresses and strains within the portrait head itself. The de-
viation from the vertical by the pendant imparts a torsion to the head: we
tend to perceive her as turning toward or away from us (and in either case
resisted by an opposing force acting either upon or from within her)
rather than statically confronting us. And against the tendency of the
brilliant yellow of this spreading counterweight to surge forward into the
light it reflects, and thus rotate her away from us into the void at the left,
the limpid, absorptive blue that wraps her head recedes in counterclock-
wise circles into the background shadows, holding the face steady, turn-
ing it tenderly toward the light.[19]

As the yellow of the pendant opens itself to the light that illuminates
the canvas, it provides a counterpoint to the ambiguities of exposure and
manifestness that haunt the face. A strip of blue even borders this portion
of the turban in a manner comparable to the way the head grounds and
recedes from the face. Yet here again the relationship is as much by way of
contrast as sympathy: its inert texture responds to the light with a lu-
minosity less equivocal than that of the face. Both are equally extreme

definitions of the foreground of the painting, yet the face seems to hesitate on a plane just behind the falling part of the turban. In comparison to the way the yellow of the pendant stands out against the background of the painting, the face can be felt to be shrinking from us, clinging to the head, attempting to wrap itself around it like the blue circles of the turban. Through its very featurelessness, its immunity to the human gaze, this yellow plummet achieves the foreground, and the light that comes from beyond it, with a completeness that the soft, vulnerable responsiveness of the face can never quite manage, even when the forces that flatten it on the canvas are felt to be most strenuously engaged.[20]

THE "TEAR-LIKE" PEARL. The pearl is suspended in a calm, still pool of recessive space carved out of the conflicts and resistances that charge the surface of the canvas.[21] It hangs free, yet at the same time nestles up against the hollow of the neck—tentatively evoking, in the midst of a painting that otherwise sets extreme of immediacy and remoteness against each other, the reassurances and consolations of a benign, stable, middle distance. (We normally think of Vermeer's entire world as inhabiting just such an imaginatively achieved middle distance. One could entertain—if as nothing more than a heuristic fancy—an analogy between this pearl and that world, and think of the painting as a whole as a mapping of the vast, restive forces within which such images of satisfaction as *Woman in Blue Reading a Letter* and *Woman Pouring Milk* are suspended.) Reduced by the light to scarcely more than a transparent, liquid glimmer (a few of the lightest, vaguest touches of paint are all that serve to indicate its presence), it yet makes itself felt as a concentration, a condensation—of value as well as substance. It alone of all the elements of the image achieves an unequivocally true, stabilizing vertical; and in its pull against the delicate register of the earlobe—it hangs much further from the ear than Vermeer's other pearls, and in contrast to their relatively weightless ovoid shape, tends in its drop toward the heavy fullness of a sphere[22]—it conveys a visceral experience of weight and volume in many ways more convincing than the massive, lazy fall of the turban's pendant.

The partial transformation of this pearl into tear-likeness generates tensions that lie close to the heart of the painting. Both tear and pearl are emblems of singleness, separateness, aloneness. But the pearl is hard, solid, durable, complete; while the tear it resembles is fragile, momentary, still (and always) in process. The one is a sign of an emotional disturbance, a cathartic rending outward, a break with the organic duration in which the figures of *Woman in Blue Reading a Letter* and *Woman Pouring Milk* take root; the other is born from the slow, cohesive time of gestation and self-reparation.[23] As a tear it clings precariously to the human subject ("It seems she hangs upon the cheek of night . . ."), metonymically bonded to a disruption of the inner life; as a pearl it hangs calmly and exotically apart (". . . as a rich jewel in an Ethiop's ear"), whole unto itself, an object of desire and at the same time a rebuke to human imperfection and its desperate, grasping needs.

There is, moreover, within the metaphorical tear itself a dialectic of vertical pull and spherical insistence that both mirrors and inverts the dynamic embodied in the two parts of the turban. While the tensions that accumulate in the circles of the turban and the knot that secures them are discharged in the easy fall of the pendant, the pearl/tear grows heavy and full as it descends through the spherical resistances that strain upward against it. Against the sense of finality, and the grace of an ultimate letting-go evoked by the plummet of the turban, it poses delicate suggestions of a deferred or suspended inevitability, and marks the precarious, charged threshold of the about-to-fall. It thus locates in microcosm the dialectic between fullness of being and imminent loss that broods over the creative act in *Head of a Young Girl*. Pregnant and heavy (even overburdened with fullness, as if the moment of its natural fall were already past), it appears to be held in the space of its last possible instant, as if it might be possible there to value it as something whole and autonomous yet still preserve its expressive link with the subjective experience that coins it. Another instant and it will detach itself, attain the purity of the sphere; yet that will be the moment of its fall, away from its origins in human grief, and toward its own dissolution—itself the cause of another grief.

From the way Vermeer has emphasized its distance from the ear, and all but elided any trace of what holds it there, it might already be falling.[24]

At the threshold of this fall, the lateral, temporizing force of metaphor intervenes, not so much annulling as diverting it: the tear is displaced from eye to ear, transformed into a pearl.[25] The passage from transience to permanence, from a subjective mirroring to an object relation, from personal sorrow to a hard, impersonal beauty, is seemingly achieved. But in the process the pearl takes on the qualities of what is elided in it. Its tear-likeness betrays, in the very place of art's triumph, a reluctance and a powerlessness at the heart of art's transformative urges. It condenses, renews, and gives visible form to the grief and troubled conscience that are transcended in it. In this it is like *Head of a Young Girl* itself, where the author's "parental" care for the life and the purity of his creation, already overdetermined by a desire for erotic fulfillment, becomes implicated in an unwillingness to let go, to deliver over into representational otherness. It is as if there can still be felt within the finished painting a conflict between the slow, loving, self-forgetful time of bringing it into being, and the spectatorial instant of confronting it as an accomplished work of art, immaculate, closed, apart, abandoned at the threshold of life. A desire to remain lost in an open, endlessly prolonged act of creation is defeated by a knowledge that creation is from the beginning an act of parting, and that the destiny of those who work within it is to confront not life but death, loss, and their own subjective isolation.[26]

It is well to remember that Plato banished the poets from his ideal state not just because they trafficked in falsehoods and created only images of things, but also (as if there were a connection) because they dwelt on sorrow and went out of their way to keep loss fresh. *Head of a Young Girl* might for all the world be the image etched on the retina of Orpheus when he looked back to make sure that Eurydice was still there behind him. Yet while we look, can there be any question of priorities, whatever the unrest that stirs in us? In front of perhaps no other painting is there such a feeling that here, before the eyes, what is desired has been found. We lack only the means to reach.

ART
AND
SEXUALITY

In public, we had our little
collusions; a wink would be enough.
In a store, in a tea-shop, the
salesgirl or waitress would seem
funny to us; when we left, my mother
would say: "I didn't look at you.
I was afraid of laughing in her face,"
and I would feel proud of my power:
there weren't many children who could
make their mother laugh just by a look.
We were shy and afraid together.
One day, on the quays, I came upon
twelve numbers of Buffalo Bill that
I did not yet have. She was about to
pay for them when a man approached.
He was stout and pale, with anthracite
eyes, a waxed moustache, a straw hat,
and that slick look which the gay
blades of the period liked to affect.
He stared at my mother, but it was to
me that he spoke: "They're spoiling
you, kid, they're spoiling you!"
he repeated breathlessly. At first

I merely took offense; I resented such
familiarity. But I noticed the maniacal
look on his face, and Anne Marie and I
were suddenly a single, frightened girl
who stepped away. I have forgotten
thousands of faces, but I still re-
member that blubbery mug. I knew
nothing about things of the flesh, and
I couldn't imagine what the man wanted
of us, but the manifestation of desire
is such that I seemed to understand,
and in a way, everything became clear
to me. I had felt that desire through
Anne Marie; through her I had learned
to scent the male, to fear him, to
hate him. The incident tightened the
bonds between us. I would trot along
with a stern look, my hand in hers,
and I felt sure I was protecting her. Is
it the memory of those years? Even now,
I have a feeling of pleasure whenever
I see a serious child talking gravely
and tenderly to his child-mother.
I like those sweet friendships that
come into being far away from men
and against them. I stare at those
childish couples, and then I remember
that I am a man and I look away.

JEAN-PAUL SARTRE, *The Words*

I

PAINTERLY INHIBITIONS

Of all modern painters, it is Degas who has most to tell us about Vermeer. The comparison could be sanctioned on technical grounds alone, yet what most profoundly links the two artists is an emotional affinity. In both there is a curiosity about feminine realms and rituals, an insistence on the distance that separates the artist/viewer from them, and a deep erotic investment in the aesthetic space that results from these preoccupations. The nudes of Degas' last period, especially, seem in their quietly charged solitude to answer to the same emotional and psychological pressures that underlie Vermeer's paintings of female privacy. Given this affinity, it is initially disconcerting, then gradually revealing, to discover that these nudes have been traditionally viewed as the expressions of a misogynist. No one would think of attributing misogynistic impulses to the painter of *Woman Pouring Milk*; yet the issues involved in this (mis)interpretation of Degas lead directly to the heart of Vermeer's achievement.

The habit of viewing Degas' nudes as acts of aggression and contempt originates with his contemporary, J. K. Huysmans, who, projecting the fashionable misogyny of *A rebours* onto the artist, found in the paintings a spirit of "lingering cruelty" and "patient hatred," and characterized them as strategies for degrading women by submitting them to humiliating postures and activities that expose sad, graceless flesh beneath their cosmetic deceptions.[1] The paintings have proved extraordinarily vulnerable to this account of them. Even today it remains more or less the standard view; the passages below are exceptional only in the degree of subjective energy invested in them:

> . . . there is, with Degas, dried-up will power, and a line that cuts like a knife. . . . The angular and flabby bodies squatting in the pale metal of the tub with its splashing water, render hygiene as

sad as a hidden vice. He shows us meager forms with protrusive bones, a poor aspect, harsh and distorted, of the animal machine when it is seen from too near by, without love, with the single pitiless desire to describe it in its precise action, unrestrained by any sense of shame, and without the quality of heroism which might have been given to the all too clear eyes by a lyrical impulse. . . . As soon as his sharp eyes surprise the thinness of elbows, the disjointed appearance of shoulders, the broken appearance of thighs, and the flattening of hips, he tells of all this without pity.[2]

"Painting is one's private life." Thus, in his studies of women, whom he distorted like mysterious and vaguely hostile mechanisms, Degas revealed his true feelings, those of a misogynist and bachelor. . . . One feels ill at ease in front of this too intimate perfection of the features, this analysis which seeks to be objective when in reality it is passionate. . . . Pastels are a precious, worldly technique, well suited to the transience of the thing seen. But here we are far from the appealing charm of the eighteenth-century portrait painters. This naturalism grates, and the attitudes of women washing themselves, drying themselves, and combing their hair in which Degas persisted in his representation of the human body are the secret and pitiful avowals of a solitary man devoid of all kindly feelings.[3]

One can only defend oneself from the half-truths of criticism like this by *looking* at the paintings, and noting the delicacy and hesitancy of Degas' approach, the tenderness with which he creates for his nudes their own body, their own privacy, their own space, and the protectiveness with which he insists upon measuring and respecting the distance that separates him from them. What these canvases witness is not misogyny but its poignant, complex inverse: the artist's need to absent himself from the scene constituted by his gaze, his attempt to come to terms with sexual desire by transforming it, through art, into a reparative impulse. It is as if these images are offered to the women themselves rather than to the

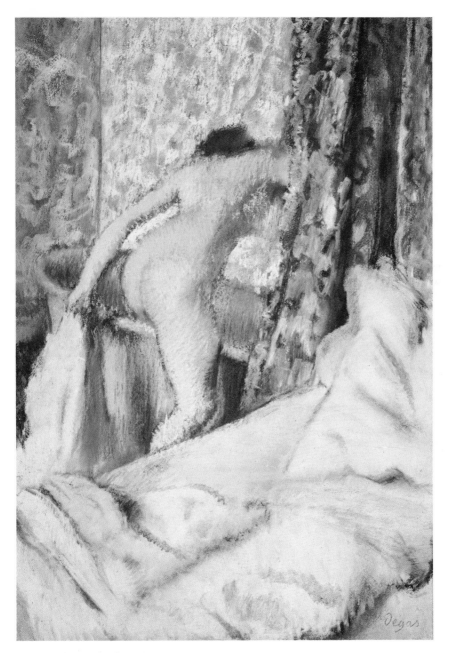

8. Degas: *The Morning Bath.*
27¾ × 17 in. The Art Institute,
Potter Palmer Collection, Chicago

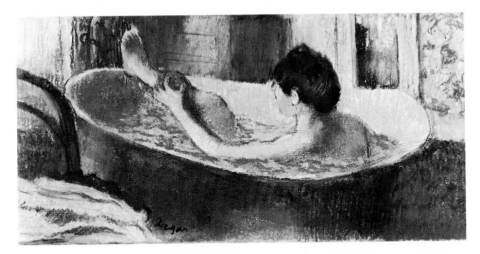

9. Degas: *Woman in Her Bath Sponging Her Leg.*
7½ × 15¾ in. Musée du Louvre, Paris

audience that beholds them. They are rendered as physical beings in their own right rather than as projected, complicit objects of masculine desire (even though the painter's erotic investment in them is obvious), delivered not only from the male gaze but from any introjected awareness of it. Degas' violation of the traditional canons of visibility does not entail, as Huysmans proclaimed, an aggression on the idea of feminine beauty per se—for again, one has only to look to discover one breathtakingly achieved image after another of poise, balance, and grace—but an insistence on locating it in the woman's own intrinsic experience, in the mundane, unselfconscious life of the body. Even the "contortions" to which he so often subjects his models almost always wind up conveying the wholeness of the body, and the quiet exhilaration of being stretched out, fully extended within it.[4]

Yet there is something about these paintings that reinforces the image of Degas the sterile, isolated bachelor. Their atmosphere is one of primal discovery and arrival: the realm of grace opens before the artist—but

28

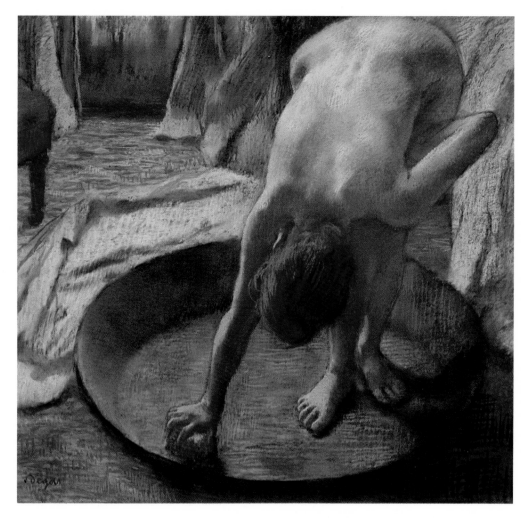

10. Degas: *Woman Standing in a Tub*.
27½ × 27½ in. Hill-stead Museum,
Farmington, Connecticut

upon moments from which men and all thoughts of men have been excluded. The sense of erotic fulfillment that enriches and intensifies these canvases is predicated on a denial of masculine will, desire, and, above all, sexual presence. Degas' privileges as an artist stem from and reinforce his ontologically negative sense of himself as a man. As a result, the sensation of creative fulfillment that the paintings communicate is haunted by the ghost of someone still there, looking, watching, invisible and excluded.[5]

Robert Greer Cohn has described Flaubert's relationship to his female protagonist in terms that may help us understand what is happening in these paintings, with regard both to the resolution they achieve and the spectatorial uneasiness they generate:

> Flaubert, as is well known, had been bullied by his friends into renouncing his well-known romanticism, so it came back with a vengeance, like the banished demon of the Gospels, in this restrained, complex, ashamed, and profoundly accepted form. Keeping his distance from his anima or heroine by cruel lucid irony, the virile creator in him thus paid the price that allowed the timid tenderness to flood back, via a back route, into our unsuspecting and gradually grateful readers' souls.[6]

Degas' objectivity is the inverse of this. The distance that separates him from the women of his paintings is a distance imposed by the artist between his animus and what is being accomplished in his work: it places his models out of reach of the methods and energies through which Flaubert *achieves* his distance. What immediately, even unsettlingly strikes one about Degas' nudes (in spite of the fate they have suffered at the hands of art criticism) is how safe they seem, how apart they are in their unguarded self-absorption from any eye that might attempt to dissect them, distort them, appropriate them into either sexual fantasy or abstract form. Yet it would never occur to us to remark how "safe" the nudes of Renoir are, though on reflection that seems as true as it is irrelevant to the impression they make on us. The very capacity of Degas'

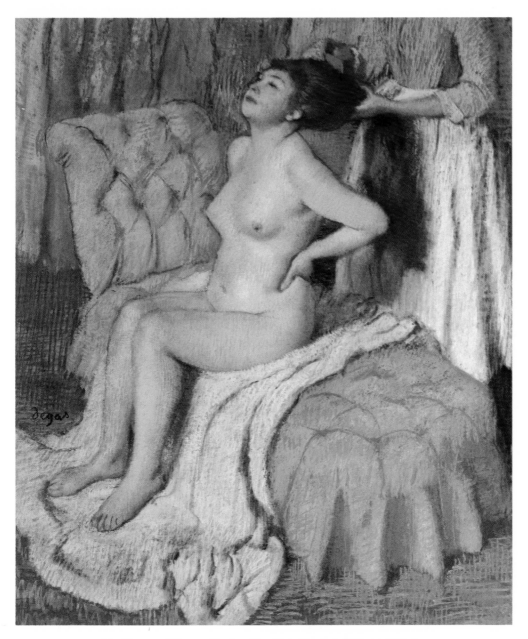

11. Degas: *Woman Having Her Hair Combed.* 29⅛ × 23⅞ in.
The Metropolitan Museum of Art, New York (Widener Collection)

nudes to move has to do with the way they cathect the viewing situation, and subliminally evoke all that is potentially negative about it. The temptations of voyeurism and its underlying Oedipal nostalgias are transcended in the creation of scenes untroubled by the onlooker's presence; the impulse to objectify, attack, or degrade (sometimes the underlying sadistic fantasy is still visible) is made to yield an act of love and generosity, an acknowledgment of wholeness and otherness.

Degas may thus achieve (but for whom, as whom?) genuine liberation of and from the romanticism that in Flaubert (in *Madame Bovary* at least) continues to suffocate and eat away at life, in both its mocked and its secretly reappropriated forms. His canvases, with their seemingly inexhaustible views of female rituals of bathing, washing, drying, cleaning, toweling, and combing, accumulate to bring about a genuinely ablutionary vision: they become ritual purifications of the space in which they are conceived. Disencumbered of all excrescences of guilt, shame, and embarrassment, the flesh glows with innocence. The imagination breathes (and sensually revels) in an atmosphere that is clear, fresh, new.

Yet Degas was able to achieve this communion with women and with the feminine in himself only by exacerbating at the level of self-commentary the image of the anti-sentimental, ruthlessly aggressive eye of the male animus. "I show them deprived of their airs and affectations, reduced to the level of animals cleaning themselves." This is the statement of an artist who is aware of the nature of his achievement, but who, in order to paint, has to keep at a distance from it, ward off its threat. What we receive from Degas, as from Flaubert, is a function of something denied by the artist to himself (and of course we are an element of the structure of Degas' authorial consciousness, just as Degas is a facet of our spectatorial awareness). And this denial seems for Degas ultimately more radical, more absolute, than it is for Flaubert. Flaubert, through his complex betrayals of his heroine, displaces onto her, or onto the structure of his presentation of her, his own inner conflicts, to such an extent that he can say, not simply but in all sincerity, "Madame Bovary, c'est moi"; while Degas is compelled to stress over and over again the unrelatedness

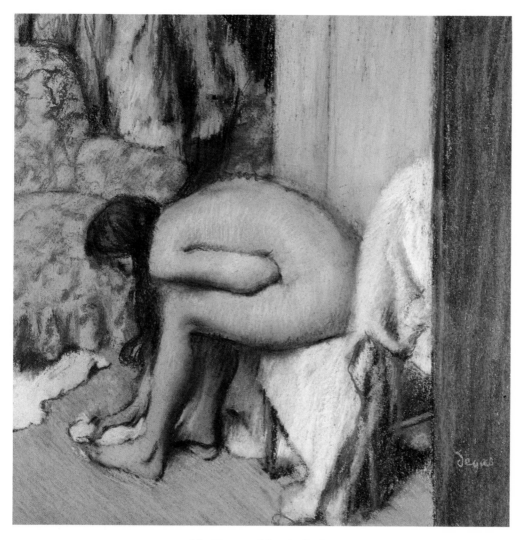

12. Degas: *After the Bath*.
21¼ × 20½ in. Musée du Louvre, Paris

to him of the anonymous models invited in off the street to serve as pretexts for experiments in form and color, even though his relationship to them as artist is one of fidelity and intimate communion.

To turn from Degas to Vermeer is as if to make a final renunciation, and thereby take a last step, into finished creation and full, integrated consciousness. Compare, for instance, *After the Bath* [12] and *Woman Holding a Balance* [13]—paintings that represent both artists at the height of their achievements. The Vermeer can in comparison seem for a moment almost hard, cold, and distant, so uncompromising is its existence as something painted, so complete its autonomy from the viewer's gaze. The pathos of nearness and distance that one still feels before the Degas—the lingering desire of the artist not so much to possess as to prolong, to *be* there where his vision is—has been completely vanquished or transformed by the Vermeer. Indeed, part of the aura of contentment and well-being that radiates from the painting has to do with a self-contained celebration of its own freedom, a happy sense of itself as something complete and apart.[7]

A letting-go, then, and with it a decisive experience of access and relatedness. Vermeer's distance, although it is as emotionally charged as Degas', transcends pathos altogether. It becomes the medium of a mutual acknowledgment, a marriage of male and female aspects. Across it love *circulates*. Look at the expression on the face of the woman in *Woman Holding a Balance*: in some only half-figurative sense she knows that we are here, and accepts, even sensually absorbs, our presence. She lets us in, while at the same time gently deflecting our gaze to the scales with which she seems to weigh, again only half figuratively, something in our attention to her. These scales become both symbol and focal point for the perfect relatedness achieved in the painting. As our gaze is united with hers in a common object, her secret (whatever it may be) becomes ours as well. However distant she may remain to us, we inhabit together the silence of an open, fully articulated understanding.

And Vermeer is perfectly aware of all this. Although *Woman Holding a Balance* taps emotional currents that run as deep as those of the Degas, it is ultimately more an *act* of consciousness than something to be kept from it.

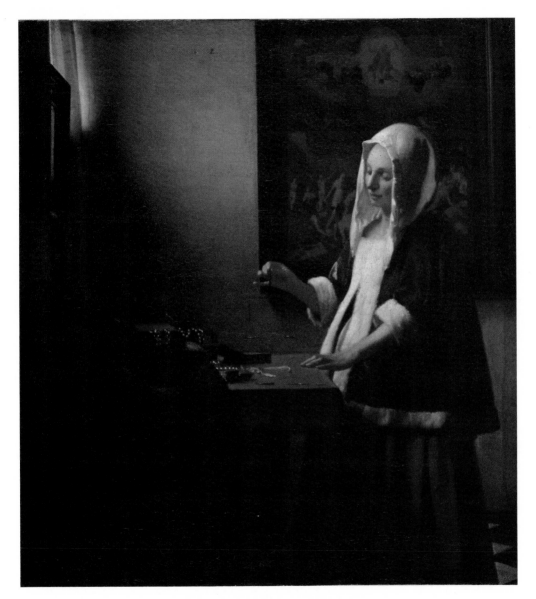

13. Vermeer: *Woman Holding a Balance*.
16½ × 14¾ in. The National Gallery, Washington

Every element in such a Vermeer suggests the presence of intentionalized awareness—as if the paintings were reflections upon themselves. Thought seems their very substance. Degas' nudes are variations on an emotional experience that must (and can) be endlessly renewed and reenacted; Vermeer's standing women are facets of a single, meditated idea that at some point can (and must) be given over, as something fully rounded and complete. One of the things we value Vermeer's paintings for is their conviction of a oneness of sensual, emotional, and reflective experience, their sense of a vision not only undergone but possessed and understood.

Yet one has only to look at Vermeer's early paintings to realize that his freedom from what troubles Degas' vision is not given but achieved. In the beginning the problematic of his own onlooking male-authorial self is perhaps *the* crucial issue of his work. The first of his many paintings of feminine solitude is *Diana and Her Companions* [14]. Implicit in the subject is the theme of the artist as Actaeon; and the way Vermeer transforms what is in his source a simple mythological tableau into something intensely *beheld* within a hushed and fragile stillness has the effect of intentionalizing this theme, making it a facet of the conscious thought of the painting.[8] Similarly, the barriers that are so elaborately built up in the foreground of his first painting of a single standing female subject, the Dresden *Letter Reader* [15], appear to serve the same defensive purposes as those with which Degas excludes himself from the space of *The Morning Bath*. These paintings tend to isolate rather than release the viewer, and focus rather than transcend his hiddenness. Elements of self-denial and distrust both inhibit and intensify the act of looking. One feels that the sort of open disclosure of artist to subject that characterizes *Woman Holding a Balance* would in these early paintings be as disruptive to him as it would be destructive to his vision.

In the majority of the early paintings, the depicted situation itself provides the occasion for what tends to be a negative identification on the part of the artist: men either paying court to or supervising women, waiting upon them—worldly, overshadowing, equivocally motivated

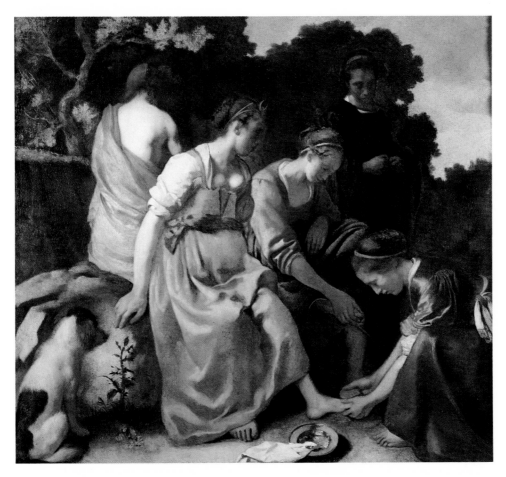

14. Vermeer: *Diana and Her Companions.*
38¾ × 41⅓ in. Mauritshuis, The Hague

visitors who are usually encumbered and ill-at-ease in a space that tends for the woman to be a natural, often aggressively protective habitat. Vermeer's capacity for negativity is uncomfortably evident in the three closely related genre scenes, *Woman Drinking with a Gentleman, Gentleman and Girl with Music,* and the Brunswick *Couple with a Glass of Wine.*[9] In these paintings, the attention that man pays to woman—acutely isolated by Gowing as the theme of all Vermeer's work[10]—elicits from the painter a deliberately acid response. All three give the impression of unhappily willed failures, rather than just immature or otherwise inadequate attempts at a conventional genre scene.

In the Berlin *Woman Drinking with a Gentleman* [16], the two perspectives on the woman—that of the man depicted within the scene and that of the artist who renders it—amount to complementary aspects of a single conflicted male consciousness. The gentleman's fixed, wholly admiring consideration of the woman is itself qualified by ambiguity: we do not know whether to read the distance from which he contemplates her in terms of motives that are romantic, purely aesthetic, basely calculating, or politely deferential. But more unsettling by far is the painter's own bad-humored indifference to the human content of the scene, and especially to that aspect of it that so absorbs his counterpart within the painting. Vermeer's unflattering depiction of the woman who has so captured the gentleman's attention seems willfully misogynistic—as if it were a negative overreaction to the spectacle of his own masculine/artistic preoccupation with woman. Her slumping posture and the decorative trim of her dress combine to give the impression of one of the least secure, fertile, or receptive laps imaginable (anything placed upon it would immediately slide off onto the floor). To grasp the full negative impact of this image within the context of Vermeer's work, one should compare it with the suggestions of nourishment, stability, and imaginative and erotic fecundity that are either evoked by or metonymically associated with the laps of the women in *Christ in the House of Martha and Mary* [47], *The Procuress* [29], *Soldier and Young Girl Smiling* [32], *Girl Asleep at a Table* [23], *Woman Pouring Milk* [5], and *Woman Holding a Balance* [13].

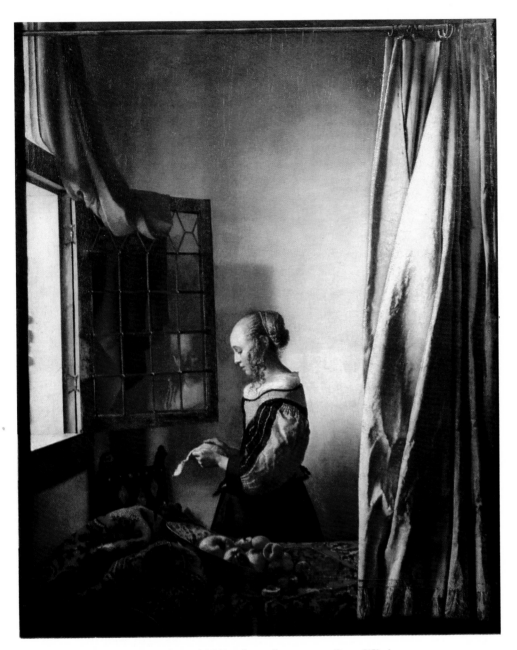

15. Vermeer: *Girl Reading a Letter at an Open Window.*
32¾ × 25⅜ in. Staatliche Gemäldegalerie, Dresden

The flattening of the woman's bodice practically to the point of concavity similarly gives the impression of being an act of aggression, rooted in the painter's own sexual inhibitions, on woman and what she represents for man. The continuous line formed by the trim on the arm and bodice of her dress binds her to the chair, and makes the upper part of her body appear scarcely more than a surrogate for the upholstered backing against which it rests. Worst of all, of course, is the disastrous effect—which gives every indication of having been calculated by Vermeer—of the wine glass she tilts against her face. The image would be perfectly at home in the *Flemish Proverbs* of Bruegel or a moral allegory by Bosch, where it would no doubt be interpreted as a representation of spiritual nullity or mindless, self-absorbed vanity.

The gentleman himself fares scarcely better at the painter's hands. His black hat (a motif, as we shall see, regularly associated in Vermeer with the negativity of male consciousness) is inimical to imaginative depth: in addition to the way it cuts into the frame of the picture on the back wall, it appears from a distance to be not so much a three-dimensional object as a hole in Vermeer's canvas. (Its opposite within the painting is the beautiful half-open cut-glass window, with its capacity to receive, absorb, transmit, and enclose all at once.) His drab cloak is wrapped around him like a straightjacket. It effectively deprives him of any interiority or embodied presence—and especially denies the existence of an arm or hand with which he might reach out to make physical contact with the object of his attention. The woman's right hand appears exactly where we might expect the gentleman's left to emerge from under his cloak. In a different mood, this detail might have tactfully suggested the existence of a secret linkage or intimacy (as does the continuous line from the woman's right hand to the man's left in *The Concert* [34]); but here it reinforces the sense of deliberate, sardonic ineptness in the handling of the human content of the scene.

Hat and cloak together work to reduce their wearer to scarcely more than his look—a distant, hovering regard. The distance measured by this masculine gaze is the most negatively rendered one in all of Vermeer (the

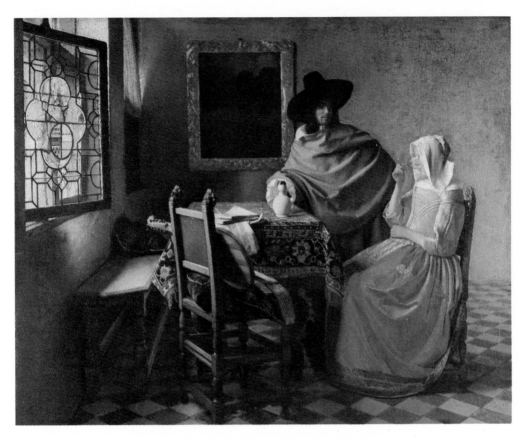

16. Vermeer: *Woman Drinking with a Gentleman.*
25½ × 30¼ in. Staatliche Gemäldegalerie, Berlin-Dahlem

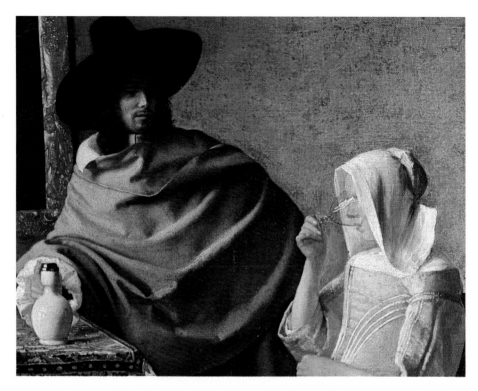

17. *Woman Drinking with a Gentleman* (detail)

cloak forms a bridge from his eyes to her hand that seems calculated to offend perception). Regardless of what motivates it, it is depicted as something that objectifies, condescends, and demeans. The gentleman's lip curls upward into an expression that threatens to read as distaste or amused contempt instead of admiration [17]—as if the misogynistic spirit in which the painter has treated the woman were latent or implicit in the very nature of the gentleman's masculine regard for her. Contemplating this male attendance on woman has led Vermeer to paint a relationship that, in contrast to the similarly inhibited but extraordinarily moving *Soldier and Young Girl Smiling* [32], contains not even the potential for responsiveness or mutuality. Human presence is here an encumberment,

an intrusion of negativity and tension into the composed realm of still life. The world of objects seems not only indifferent to the human content of this painting but actively hostile to it, as if the painter's animus had found objective embodiment there: the lion's-head finials on the back of the chair that holds the cushion and the mandolin stare angrily at the man and the woman, while the two reflected gleams on the glass from which the woman drinks stab violently at her eyes.

Gentleman and Girl with Music [18] is in many ways a resolution of the discordances of *Woman Drinking with a Gentleman*.[11] Here the human content of the scene comes forward into a warmer, more sympathetic light, as if indicating a newly enkindled desire of the painter to participate in what he describes. Similarly, the still-life of the room no longer seems to resent the intrusion of the human element, but instead clusters round it like a nest, actively empathizing with it. Descargues calls the painting "a symphony in blue";[12] equally of note is the beautiful counterpoint between the red of the woman's blouse and the rich, calm wine in the once persecutory wine glass.

The motif of benign encompassment extends to the treatment of the human figures themselves. The stiff, restrictive garments of *Woman Drinking with a Gentleman* are loosened and softened to convey a more comfortable, less repressive sense of security. The man's left hand now emerges to bridge the gap that the cloak of the former painting awkwardly maintains. Besides providing a warmer, more richly interiorized space for the man, the cloak grounds and enfolds the woman, in the space of a masculine attention that shields her from rather than exposing her to the implications of the Cupid on the wall behind her. The identical rendering of the cloak and the woman's skirt reinforces the impression of two people blending together into a single figure of intimacy. Whether the gentleman is a teacher or a suitor, his motives are not in question here; the musical occasion relieves self-consciousness, brings the man and woman close, deflects their attention from each other onto a common object, where hands almost touch. The painting appears to achieve, and be about, an aesthetic sublimation of the sexual tensions that inhibit the

43

atmosphere of *Woman Drinking with a Gentleman*.[13] As such we would expect it to exhibit a newly acquired good conscience on the part of the artist who painted the scene.

Yet such is not quite the case. For all its aesthetic advantages over *Woman Drinking with a Gentleman*, the painting ultimately gives the impression of elaborating rather than resolving the problematic of the former painting. The trouble, of course, is with the woman's look. Besides the discomfiture of being looked back at by a painting whose intimacy and fictional integrity depend on our invisibility to it, there is the ambiguous, disconcertingly neutral quality of the gaze itself: not quite either warm or cold, hostile or inviting, curious or disinterested, fixed upon an object it apparently finds neither familiar nor strange, registering an intrusion it neither especially welcomes nor resents.[14] The distancing effect, though not dramatic, is thorough and complex (one is almost reminded of Manet's *Olympia*): the place of the artist/viewer is burdened by an awkward self-consciousness (the object of our uneasiness is our own onlooking presence rather than, as in *Woman Drinking with a Gentleman*, unresolved tensions within the painting itself), and is at the same time undermined ontologically (we can infer only our visibility, not our identity or our relation to the scene, from her noncommittal gaze). The painting acknowledges us only the better to neutralize us, to define us as extraneous and intrusive.[15] It anticipates our look and flattens it, de-energizes it. We experience our viewing presence as nonconstitutive of what we behold—a negation not only of the mode of involvement that *Head of a Young Girl* thrusts upon us, but also of such accomplishments as *Diana and Her Companions* and *Woman Holding a Balance*, which, though free of us, still fill our gaze and exist within it.

The painting thus articulates, more consciously and directly than *Woman Drinking with a Gentleman*, a split within the artist over the issue of woman and the nature of his attention to her. The man within the painting is an idealized, domesticated image of both a man's relationship with a woman and a painter's with his model: at once intimate and paternal, deferential yet in control, shielding the object of his attention

44

18. Vermeer: *Gentleman and Girl with Music.*
14½ × 16½ in. The Frick Collection, New York

from Eros and oblivious to it himself, wholly and innocently absorbed in his aesthetic collaboration with her. But the direct gaze of the woman enforces the distance between the artist and this idealized self-image—to the degree that identification does occur, the woman's look reads as a displaced response to the man who bends over her (hence the popular title, *Girl Interrupted at Her Music*) and disrupts the intimacy of the situation from within.

The artist/viewer is thus relegated by the woman's gaze to a periphery he must share with the empty chair, the birdcage, and the hanging Cupid. These three objects form a darker circle just outside the sphere in which the couple and their immediate accoutrements are so intimately enfolded; each represents a perspective inimical to the idyllic relationship at the center of the painting. The naked Cupid, barely visible in the far background of the space shared by the man and woman, yet flagrantly signaling to the artist/viewer, raises the erotic issue so perfectly suppressed within the relationship itself. The birdcage, again outside the ken of the couple but prominently within the artist's view, threatens to recast the close, attentive intimacy celebrated in the central configuration into an image of subjugation and confinement.[16] And the empty chair with its menacing lion's heads, pushed back from the table toward the place of the artist/viewer, is the surrogate of an onlooking animus that has been only imperfectly banished from the painting.[17] Together they adumbrate the aspects of the artist's own consciousness that exclude him from the solution he proposes within his painting.

The problematic of *Gentleman and Girl with Music* is somewhat clarified by a painting from Vermeer's last phase, *Woman Standing at a Virginal* [20]. The Cupid reappears on the back wall of this painting, but now fully, even blatantly visible (indeed, he looks a bit ridiculously cross-eyed and bewigged now that his presence is so openly declared). Vermeer's light, instead of making its usual distinctions, gives equal value to foreground and background. The Cupid is thus superimposed on the woman's presence; and despite the obvious contrast between his exhibitionist's indecence and her uprightness, and a certain authorial relishing of the incongruity of his prominence in this of all paintings, there is a profound,

19. *Gentleman and Girl with Music* (detail)

deadpan humor (the joke only seems to be at her expense) insisting that his gaze and hers are one and the same. The somewhat intimidating expression on her face may appear to duplicate the female gaze that undermines the place of the viewer in *Gentleman and Girl with Music*, but here, near the end of the artist's career, there is an overriding familiarity about it. She clearly knows the artist well, and both takes for granted and insists on an understanding that exists between them. No metaphysical boundaries are violated as she looks back at us from within the painting: her habitat is not art but life (she is not playing the virginal, she is posing, just a bit impatiently, for a painting). She is the most formidable and at the same time least mystifiable Other, standing there not only as the

47

subject of the artist's fantasies but as a potent resistance to them as well. It is impossible to mistake *this* painting for the work of a bachelor.

The third in this early trio of genre pieces, the Brunswick *Couple with a Glass of Wine* [21], gives explicit, almost schematic representation to the conflicts embodied in both the former paintings. The two male figures are made to appear contrasting aspects or motives of a single individual, and the splitting is again precipitated by the spectacle of woman as the object of man's attention. The two oranges [22] deftly and rather sardonically counterpoint the issue, and make its applicability to the painter himself more apparent: the one untouched and whole, an aesthetic object; the other peeled and ready to eat. The mood of the painting is such that neither male aspect is allowed any positive force. The posture of the contemplative figure in the background recalls that of the solitary woman in *Girl Asleep at a Table* [23]; but his reverie, instead of opening (or rather half opening) on the luminous, imaginatively enticing realm in the background of the latter painting, is boxed into a shallow, closed space where it tends to read negatively as boredom and passive, isolated disengagement. The active, sexually aggressive figure, meanwhile, comes forward into an embarrassingly contemptuous light, an image of both petty, calculating villainy and egregiously condescending attendance.[18]

Linking the two figures, and opposed to them both, is an old-fashioned portrait of masculine uprightness—the objective correlative of the artist's conscience, an obsolescent ego-ideal that seems not only ineffectual but a bit stuffy and ridiculous as it overlooks the current scene.[19] And as if to prevent identification with this image of virtuous aloofness, or with the figure of contemplative detachment in the background, the woman looks directly at the artist, in response to the advances of her *active* suitor. (Vermeer's rendering of this central couple depends upon a half-subliminal perception for its full negative impact: the man is not merely a calculating suitor but also an artist explaining to his model exactly how he wishes her to pose for him, and the woman's response to him is not so much that of a coquette as one both flattered and embarrassed to find herself the object of an artist's attention.) The artist responds to her in

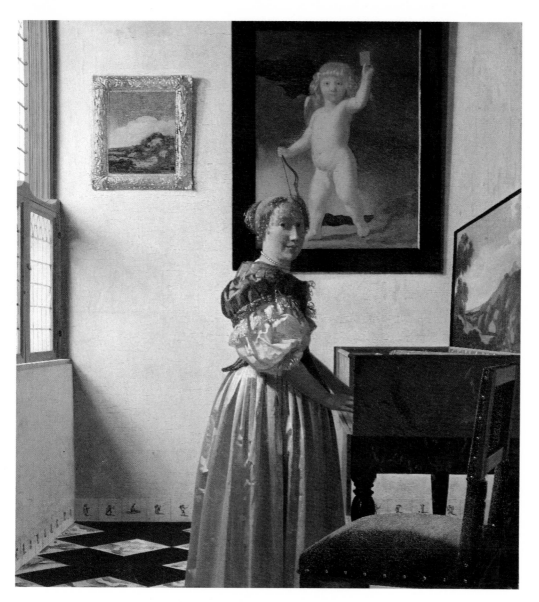

20. Vermeer: *Woman Standing at a Virginal.*
20 × 18 in. The National Gallery, London

49

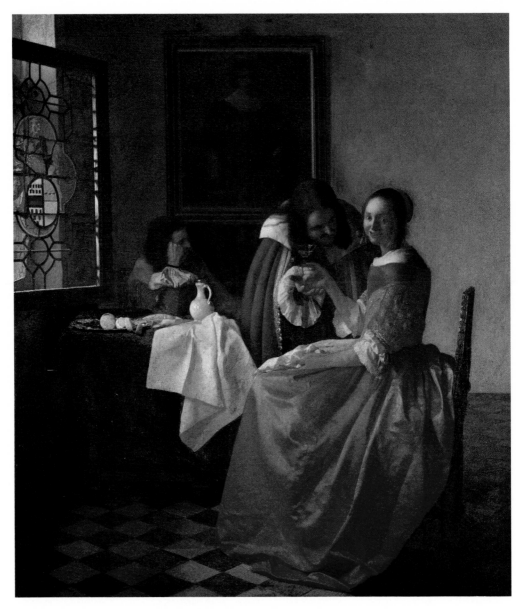

21. Vermeer: *Couple with a Glass of Wine.*
30¾ × 26½ in. Herzog Anton-Ulrich Museum, Brunswick

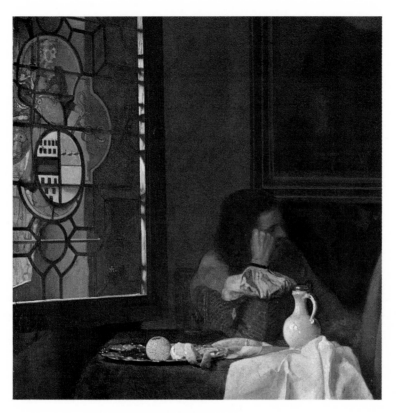

22. *Couple with a Glass of Wine* (detail)

turn with a misogynistic animus rooted in his own negative identification with the suitor who hovers so contemptibly over her.[20] Even the virtuoso display of painterly skill—the woman's richly colored, finely detailed dress, the exquisitely realized still life, the concentration of the overall color scheme in the central design of the cut-glass window—seems calculated more to emphasize the contradictions within the artistic impulse than to give aesthetic pleasure for its own sake. It is possible to appreciate these details only by fighting off the impulse to turn away in embarrassment from the painting's direct address to us.

It is only when men disappear from the space of representation, and the painter's characteristic subject changes from the relationship between the sexes to an isolated female presence, that the troubled conscience of the early paintings yields to that inner peace which is Vermeer's special gift to Western art. But it would be a mistake to view this development as simply a matter of substituting an aesthetic contemplation of woman for an attempted confrontation with the problems of achieving an actual relationship with her. The paintings of single female subjects impress us, in fact, as being somehow directly engaged with what is being kept at a distance in the genre scenes. When one turns from *Couple with a Glass of Wine* to the Dresden *Letter Reader*, certain representational defenses seem to fall away; there is something like self-acknowledgment or disclosure on the painter's part, a willingness to make himself vulnerable to the subject of his vision and his feelings with respect to it.[21]

From this point of view, the disappearance of men from the scene of representation signifies not a retreat from the sexual theme so much as an acceptance of it (and a being accepted by it), a capacity to enter directly into it instead of having to observe it from a distance through negatively depicted surrogates. The paintings themselves come to embody, in the relationship between artist and model, viewer and subject, the erotic energies that formerly they may have pretended only to represent. As this shift occurs sexuality ceases to be a threat, a negative force for the artist, even if it remains his central problem. The tensions that intrude so dissonantly into the aesthetic realm in the genre scenes are in the Dresden *Letter Reader* also, but they charge and enrich its atmosphere; Eros here is the reservoir from which the artist draws.

Girl Asleep at a Table [23] is especially interesting for its elaborate, highly conscious articulation of the relationship between viewer and subject that is more intuitively embodied in the Dresden *Letter Reader*. The lion's-head finials, even more conspicuous here than in *Woman Drinking with a Gentleman*, are turned away from the girl, as if to mark off an animus-free space both for her reverie and our contemplation of her. (Indeed, the creation of an atmosphere that indistinguishably blends her

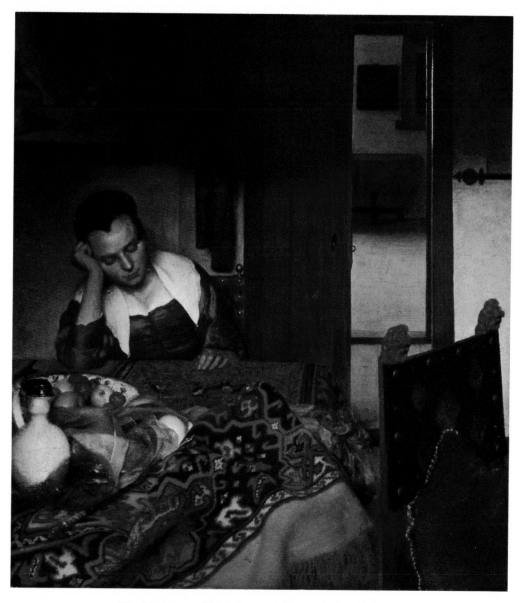

23. Vermeer: *Girl Asleep at a Table*. 34⅛ × 30⅛ in.
The Metropolitan Museum of Art, New York

reverie and our contemplation seems the essence of what Vermeer is striving for in this painting.) So positioned, they indicate a male presence somewhere in the painting's off-space—and as indicators they are subject to a characteristically overdetermined male psychology, angrily, defensively refusing entrance to the very thing they metonymically represent. But here the place indicated does not coincide with that of the artist/viewer: the barrier is pushed aside, allowing us qualified but unconflicted access to both the girl and the mysterious realm upon which the door behind her partially opens.

And now that the arrangement does not force a strict identification with what is felt to be a threat to female solitude, the possibility arises of responding to the source of the threat as itself something positive: the curving diagonal that starts at the picture of the unmasked Cupid and runs downward through the slant of the dreaming girl to the forward-straining lion's heads and beyond them to whatever it is at which they point tends to transform the finials from guardians of her inviolability into vectors of her desire. The feeling of male absence that is so intricately and enigmatically indicated in this painting (the finials, the unmasked Cupid, the open door, the cloak[?] hanging on the wall, the walking stick[22] and the overturned glass[?][23] lying on the table, all obliquely signify it) and in the Dresden *Letter Reader* is as ontologically positive as male presence in the genre scenes is negative. Male absence becomes, in Vermeer's dialectic, the space of "the feminine"—the space that the figure of woman fills, if not yet with being, then with a reverie and a desire in which being gestates.

Even the seemingly allegorical or anecdotal elements of the painting help to articulate the atmosphere of mutual openness, the symbiosis of imaginative states between subject and viewer. The mask at the foot of the Cupid in the painting above the girl's head may well be intended to counterpoint her sleep, and perhaps to give us a hint of the content of her dreams ("Sleep is revealed as the dropping of a mask, uncovering the fantasy which is the sleeper's secret, a fantasy, we may guess, of Love");[24] but it also suggests the artist's own discarded mask, his willingness to

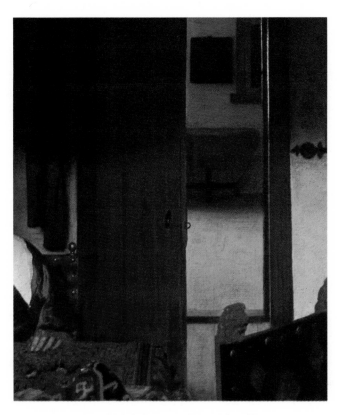

24. *Girl Asleep at a Table* (detail)

admit his erotic attraction to and investment in the object of his contemplation.[25]

The opening in the background of the painting [24] can likewise be read either as an extension of the girl's reverie, as a metaphor for her openness to us, or as the destination toward which our own contemplation tends. The private significance for the viewer of this threshold and the absence that is palpably visible beyond it is stressed in several ways. The chair and the tapestry, which at first glance appear piled up in the foreground merely to keep our attention at a distance from the sleeping

25. Vermeer: *The Procuress* (detail of 29)

girl (in the manner of the Dresden *Letter Reader*), work more subtly to channel it through the background opening. And the focal point of the painting, as Madlyn Kahr has observed,[26] is not the woman but the square shape on the far wall of the room behind the door. This distant object, which is further enhanced by being the only complete geometrical shape in the painting, proves, upon closer inspection, to be a mirror.[27]

A dialectic is thus established within Eros between the sexual motive that draws us to the girl and the material abundance that gathers round her, and a narcissistic motive that draws us even further into the depths of the painting (the mirror does not reflect our image, it beckons to us as an

26. *Woman Holding a Balance* (detail of 13)

enigmatic destination), toward a realm that is both open and empty, that evokes both the promise of light and the intimation of death.[28] The two sides of the right angle formed by the section of tapestry pushed up into the foreground precisely indicate these two vectors. The viewer's libido is admitted here, even solicited, but then gently deflected, channeled past its ostensible object toward a purely imaginative (and scarcely humanized) space that opens behind her.

In a sense the subject of the painting is the mysterious process we have learned to call "sublimation"; but if we think of it merely in terms of substitute satisfactions we will not begin to do justice to the complexities

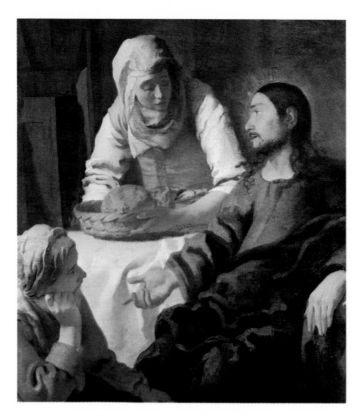

27. Vermeer: *Christ in the House
of Martha and Mary* (detail of 47)

of Vermeer's vision. True, the imagination is colored by a certain sense of grief or disappointment as it passes by the young girl on its way through the doorway into the emptiness beyond—in this, as in so many other ways, the painting anticipates *Head of a Young Girl*. Yet there is an equally strong feeling that the girl exists merely to materialize that threshold, and that it addresses the viewer's desire at a more primordial level than she does. And the composition as a whole leaves it deliberately unresolved whether the door opens on a renunciation of sexuality or as its promise, its

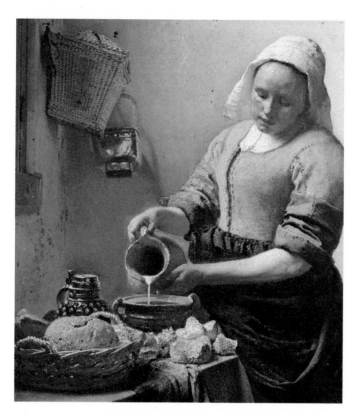

28. *Woman Pouring Milk*
(detail of 5)

"beyond." It is a question that animates the whole of Vermeer's oeuvre, one to which we will return when we come to two of Vermeer's most self-reflexive paintings, *Couple Standing at a Virginal* and *Artist in His Studio*.

In the series of single female subjects inaugurated by *Young Woman at a Window with a Water Pitcher* [53], the two realms still kept separate in *Girl Asleep at a Table* are triumphantly fused. Here, where sublimely full, free-standing women bask in the light of our attention, it is impossible to

59

distinguish between erotic and imaginative fulfillment. Although the nostalgia about male absence that burdens the atmosphere of *Girl Asleep at a Table* and the Dresden *Letter Reader* has completely disappeared from these paintings, they continue to acknowledge the erotic relationship with the artist/viewer that is mysteriously sublimated in them. The pregnancy of the woman in *Woman Holding a Balance* [26] is the strongest and least wistful reminder imaginable of an influential male absence; yet at the same time it is the consummation of her own capable singularity, an emblem of her own ontologically enriched (and enriching) presence. The look of satisfaction on her face is a refinement of the expression of sexual fulfillment on that of the woman in *The Procuress* [25]—the thin gold coins and the gap between the third and fourth fingers of the right hands are sufficient to establish the intentionality of the allusion. Both women weigh with their eyes a transaction, the emblem of a relationship, focused at a suspended yet utterly certain hand. But in the later painting, the artist/viewer himself takes the place of the amorous cavalier—providing for her a lovingly supportive space, and at the same time in complicity with her look, sharing not only its object but the secret of its confidence.

In the same way, the gesture of the woman in *Woman Pouring Milk* [28] becomes an extended, metaphysically elaborated version of the offering made by the standing woman in *Christ in the House of Martha and Mary* [27], with the viewer of the later painting in the position of the seated Christ of the earlier one. As the central male figure disappears, the two poles of feminine being that gravitate around him merge into a single, self-sufficient woman whose very presence seems to generate the nourishment that flows outward toward the viewer. Her attitude satisfies what might have been thought irreconcilable needs: she cradles the pitcher with maternal care (we take its place, we feel what it is to be held like this, to have one's heaviness made light), yet holds its interior up to our gaze with a gesture whose connotations are unmistakeably sexual.[29] The artist/viewer of *Diana and Her Companions* observes the mysteries of woman from a place of hiddenness; but here they matter-of-factly assume his presence. The realm of female sexuality in all its aspects lies open and freely offered, yet

it is discovered whole and unimpaired, at the heart of an ongoing and familiar world. One is tempted to seek the explanation for such a development in the particulars of Vermeer's life (hence the impulse to identify the women in his paintings as his wife and daughters), yet the paintings keep pulling us back into the aesthetic sphere, insisting that such grace is accomplished entirely within art, and that such art in turn makes life possible.

II

TWO EARLY PAINTINGS

THE PRECEDING DISCUSSION of Vermeer's development might suggest that his oeuvre moves toward *Woman Pouring Milk* and *Woman Holding a Balance* as an affliction toward its cure. Against so simplistic a view of the evolution of his work, we need only pose the two masterpieces of his early period, *The Procuress* and *Soldier and Young Girl Smiling*. Although these are among Vermeer's first paintings—almost certainly earlier than the three troublesome genre scenes—everything upon which his later resolution draws can already be found in them, not merely as a latent promise of things to come, but as something fully present and achieved in its own right. The unresolved tensions (sexual, spectatorial, authorial) of the genre scenes receive, in fact, their most thorough and complex representation in these two paintings—yet here, at the very beginning, they seem already to have been worked through and profoundly come to terms with. In spite of the deeply problematical vision of sexuality and the distance between the sexes that informs them, both paintings yield configurations of human relatedness that are among the most moving and valuable things in all of Vermeer. It could even be held that Vermeer never surpasses the accomplishments of these first works, and manages to return to them only indirectly, via a difficult and enigmatic process of renunciation.

Consider first *The Procuress* [29]. A first glance tends to confirm the impression of an artist more open to the problems than to the possibilities of the sexual theme. The tonal values are much darker than anywhere else in Vermeer, and the color scheme is marked by a predominance of black, a pigment that Thoré claimed to be completely absent from the artist's world. The setting itself is a brothel, and the two figures depicted on the left materialize an atmosphere of venality and concupiscence that hovers pruriently about the central theme. There is an interior, mental quality about these figures: they mirror facets of the viewer's psyche, and in so

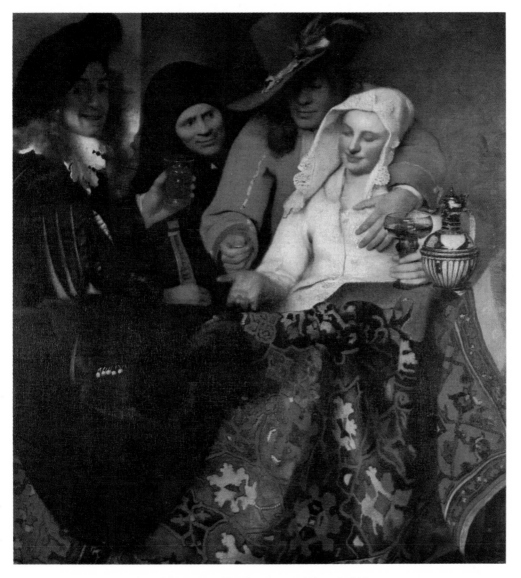

29. Vermeer: *The Procuress*. 56¼ × 51¼ in.
Staatliche Gemäldegalerie, Dresden

doing indicate the presence of bad conscience and sexual unease within the painting. We might be tempted to conclude that it transcends typical Dutch brothel scenes [35] only by virtue of being a neurotic response to what they all so casually depict.

And yet: as our first glance deepens into an extended viewing, everything begins to change. The richly satisfying nature of the relationship between the man and woman on the right eventually begins to assert itself and draw us deep within it, on its own terms [30]. One is struck by how miraculously uncontaminated it remains, either by its setting or by the dark figures who gather round it, and how much this counts for in the way of value. Within the experience the couple share they seem invulnerable (and oblivious) to both the voyeuristic and the moralistic gaze. And the important thing is that the painting achieves uninhibited, intuitively convincing access to this experience. The artist may identify with the self-conscious cavalier on the left (and insist on our complicity with him as viewers), but the painting itself, with its rich, unabashed sensuality (even the darkness is eroticized: note the frankly sexual connotations of the way the black cloak covers the richly colored tapestry), finds its source in the woman on the right. The force of her presence transfigures even the structure of the painting: against the left-to-right movement that arrives at her as a compliant object of vicarious fantasy and sexual desire, she becomes a radiant center about which the other figures gravitate, in increasingly dark and frigid orbits. And for the only time in Vermeer, a man occupies a privileged position within this enhanced feminine sphere. Unlikely as it may at first seem, there lies at the heart of this painting, as if on the other side of moral prejudice and sexual inhibition, what may be the most unsentimental, guilt-free, spiritually satisfying representation of shared erotic experience in all of Western art.

No painting, in fact, suffers more from the necessity of attaching a name to it than *The Procuress*. The conventional title falsely stresses the theme of venality, and misleadingly refers to a narrative dimension that has been all but eliminated in Vermeer's treatment of the subject.[1] If the viewer happens to identify the woman on the right as the "Procuress" of

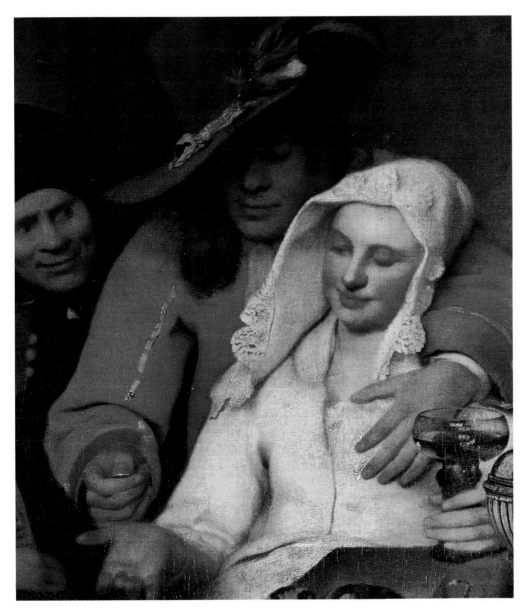

30. *The Procuress* (detail)

31. *The Procuress* (detail)

the title, and then invents a fitting anecdote to explain the exchange that passes between her and the man who leans over her (does he merely toss a coin into her palm with a knowing squeeze as he goes off to take his pleasure with one of her charges?), he will miss the depth of the erotic bond that unites them, and the level of phenomenological immediacy at which it is conveyed. Vermeer is interested in depicting not a visit to a brothel but sexuality itself—not so much how it looks as how it feels, how it *is*, as well as what threatens it, both from without and from within.

Even a neutrally descriptive title like "Man and Woman Exchanging a Coin in the Presence of Two Onlookers" would be too external, too

exclusively visual to indicate the endopsychic level at which Vermeer's image registers. The complicity between the couple goes deep, in spite of the air of casualness it projects, and the mood that envelops them is one of consummation rather than anticipation, however an anecdotal reading of the painting might insist on having it. That Vermeer situates so romantic an image of erotic fulfillment in the context of "Venal Love" indicates his commitment to the value of what is bestowed by actual (one might almost say impersonal) sexual experience, his freedom from the need to contain and valorize it in terms of a more conventionally humane, ethically intelligible relationship.[2]

Yet Vermeer does go out of his way to bring into play the attitudes that his own way of seeing transcends. Consider his treatment of the pitcher that stands at the far right, beside the woman's glass [31]. It has been placed in the most precarious position imaginable, at the very edge of the table, almost touching the back of the hand that absent-mindedly grasps the wine glass. At first glance, disaster seems imminent, especially in the context of such sensual, perhaps even slightly drunken abandon. The very composition of the painting—the flow of attention from left to right, the sequence of overlapping hands and glass crowding, domino-like, into the pitcher's space—seems to conspire with the viewer's own kinesthetic impulses to topple it over onto the floor. The temptation is to find in this detail a warning, even the key to a full-fledged moral allegory, and there exist countless drinking scenes by Vermeer's contemporaries that could be marshaled in support of such a reading.[3]

Yet as we continue to look, the pitcher continues to rest in its place, with the same centered, imperturbable calm that similarly begins to characterize the woman's presence. Her certainty of self and gesture gradually disarms the anxiety located by the pitcher and her nearness to it, and allows a more benign counterpoint to grow between them. Indeed, the pitcher's uprightness and intactness in the midst of a sexual relationship may well signify an argument against conventional morality. Erotic experience here, at least insofar as it is the woman who arrests our attention, has to do not with loss of virtue but with fulfillment and sureness of being.[4] All things considered, the detail seems less that of a

moralist than of an artist confident in the capacity of his vision to triumph over both conventional attitudes and his own inner demons.

Thematically, *The Procuress* is organized around the ambiguities of participating in another's experience. (It is characteristic of Vermeer's thought that he should approach the issue of sexuality in such terms.) This can be seen most clearly in the left-to-right movement of the painting. The four central figures form a spectrum leading simultaneously from vicariousness to self-absorption and from isolation to relatedness. (That the woman functions as an extreme of *both* self-absorption and relatedness suggests the resolution in her of a fundamental human paradox.) And at the level of our own engagement with the painting this spectrum involves a passage from bad to good conscience—with uneasy specular identification at one extreme and erotic investment in (and access to) experience radically other than our own at the other. The stages of this passage suggest both a continuum—note especially the progression of lips, as well as the gradual centering of attention on the woman—and a division into separate, unbridgeable worlds of darkness and light, spectral light and sensual, fully embodied plentitude.

The two figures shrouded in darkness confront us with negative images of the authorial and spectatorial aspects of our own presence to the painting. The cavalier on the left wears the same costume as the artist in Vermeer's later, more openly self-conscious *Artist in His Studio* [41], and has been identified by several commentators (largely on the basis of this internal reference) as a self-portrait. Arbitrary though it may be to take this figure as autobiographical evidence of what Vermeer himself looked like, certain details—the lute that he holds in his right hand, his direct complicity with the audience of the painting, his self-conscious sense of himself as presenter or celebrator of its revels—do suggest a mirroring of the artist qua artist.[5] He would obviously like nothing more than to feel himself at home in a typical Dutch genre scene of the "Merry Company" variety. But in the context Vermeer has placed him, he seems a superficial, isolated figure, cut off from the sensation of deep selfhood that the couple on his left experience through sexual contact. The slightly forced, tentative quality of the libertine pose he strikes undermines its intended

effect, and betrays an insecurity and embarrassment beneath it. His overeagerness to be a part of what is going on, and his sense of himself as in complicity with an audience external to the scene, are both symptomatic of his alienation, and even appear in part to be defensive measures against the flesh-and-blood experience of sexuality (and authentic, deeply committed relatedness) to which he is vicariously drawn. Poignantly, even the objects he holds in either hand, which should be emblems of participation, only further isolate him from the possibility of real human contact, as the contrast with the beautiful interlacing of hands between the couple on the right emphasizes.

A dim view, then, is taken here of the vicarious, compensatory nature of art: the artist is portrayed, especially in comparison to his worldly, self-assured counterpart, as something of a permanently arrested adolescent, whose art, if we are to judge from the way his hand grasps the emblematical lute handle, has strong masturbatory connotations. The ultimate paradox, which Vermeer makes no attempt to resolve, is that the painting within which this negative view of the artist's relationship to erotic experience is presented is deeply in touch with that experience. Indeed, the life that evades the artist takes on the quality of an epiphany largely because we come upon it within art, and feel it to be an aesthetic achievement.

If the cavalier on the left mirrors the artist's negative sense of himself, the dark figure next to him functions similarly with respect to the viewer. The black in which Vermeer has shrouded her(?) negates any sense of bodily presence, and reduces her to a hovering, voyeuristic regard. We see eyes greedy for, and jealous of, what only hands can experience. There is something similarly sinister about the sexual ambiguity of this figure; it underscores by way of contrast the affirmations embodied in the couple on the right (the absence of hands functions similarly): in this case, a stable differentiation between masculinity and femininity, as well as a satisfying sense of "fit" between them.

This figure also occupies an ambiguous place in the structure of the painting. She definitely belongs to the dark half of the composition, and her link with the cavalier on the left is reinforced by our tendency

69

(obviously calculated by Vermeer) to attribute the hand holding the lute to her rather than him (an ambiguity that makes the masturbatory connotations of the image even more disturbing). The upper background, however, isolates her from the cavalier, and stresses instead the diagonal that links her with the couple on the right. The meaning of the latter arrangement is elusive, but two possibilities come to mind.

First, it allows us to read the figures on the left as two aspects of a single bad (male) viewing conscience, corresponding to the splitting of male presence within the painting. The cavalier on the left, that is, would embody a compulsively narcissistic ego, visually alienated in mirror-relationships; while the shrouded figure next to him would represent a deeper, id-like viewing presence, hovering pruriently just over the shoulder of the active self, even in its moments of least self-conscious, most instinctually satisfying sexual engagement.

Second, it emphasizes the asymmetry of the relationship between the couple by inscribing it within a continuum of vicarious desire tending from the shrouded figure toward the woman on the right. For as satisfying an image of sexual union as that relationship offers us, it is still a difference between male and female desire that Vermeer calls attention to within it. Both the man and the woman incorporate an imagined or intuited awareness of the other's presence into their own sense of themselves within the relationship (one effect of the circumvention of direct eye contact is to give full weight to the imaginative dimension of the relationship, and to the rich, non-visual interiority and privacy of self it implies); yet the ways of access to this otherness, and the modes of relating to it, differ significantly. Her experience is primarily of herself, securely installed at the center of things (a sensation eloquently underscored by the detail of the hand lightly grasping the androgynous wine glass); he is present to her almost auto-erotically, as a kind of surrounding yet at the same time immanent, internal erotic space (she seems to register the hand that rests upon her breast at the quick of her being rather than on the surface of her body). He, too, experiences her almost auto-erotically, incorporating her presence to him as if it were a component of his own

absorption in himself. Might not the pitcher, by one of Vermeer's tactful displacements, represent what he psychically as well as sensually experiences as he places his hand on her breast?[6] But he is also more vicariously centered on her than she on him—conscious of her experience of him (whereas she does not seem to consider his of her), and aware of himself as evoking it in her. We can thus read the linear organization of the four figures in still another manner, as one pair bracketed by another: the suitor in red providing a benign counterpart to the vicariousness of the shrouded figure next to him, and the woman who is the object of his attention similarly balancing the narcissism of the cavalier isolated on the far left.[7]

These two experiences mesh in such a way that ideals of union and separateness reinforce rather than contradict each other. She leans back against his arm sufficiently to communicate to him her responsiveness and casual trust in his presence, yet not to such a degree as to disturb her own inner equilibrium; he leans forward to surround her, yet without encumbering her or encroaching on her privacy, and equally without jeopardizing his own center of gravity. Together they occupy a space apart from and in the background of that aspect of their transaction that visibly passes between them, and from their vantage point they observe it serenely and somewhat enigmatically, almost ironically enjoying in it a meaning that necessarily escapes the external view.

A final word needs to be said about the hand that rests upon the woman's breast. It is an openly erotic gesture, no doubt intended by the man and received by her as such. The hand is not at all subtle (as the contrast between it and the finely rendered hand involved in the exchange of the coin emphasizes), yet there *is* something infinitely subtle about the way it seems to reach its destination with as little will, and as little attention to ends, as possible. One of the things that makes the gesture so moving, in fact, is the sense of utter fortuitousness about it. It is as if in putting his arm around her, his hand just happened to fall upon her breast—as if it were not a gesture at all but merely a matter of the perfect fit between them. What is at stake in this fiction is not merely tact

but metaphysical belief: sexual experience is relieved of the burden of will, and inscribed within an order (the steady wine glass and the coin about to drop into the woman's palm, as well as the arm around her shoulders, all testify to it) in which things fall as if by random into their natural, preordained resting places. The sexual configuration here presents us with an image of what it feels like to be in the world, and be assured of it.

With *Soldier and Young Girl Smiling* [32] we move closer to the problematical focus of the genre scenes. Whereas the couple of *The Procuress* describe "the lineaments of gratified desire," the man and woman here remain apart, suspended in a complicated atmosphere of anticipation and restraint. Yet the ill-at-ease of *Soldier and Young Girl Smiling* is predicated on an interweaving of male and female aspects more complex, and more sympathetically observed, than anything to be found in the later paintings. Even if the vision of the whole remains that of a man hesitating on the threshold of his desire, drawn back into a shadow he inadvertently casts upon himself, the fragile equilibrium that assimilates his presence is as moving, and counts for as much in the way of human value, as anything to be found in Vermeer.

Soldier and Young Girl Smiling creates, like *The Procuress*, two distinct impressions, the second of which tends to contradict and revise the first. Its composition tends initially to force a partial identification with the soldier—even if our attention is drawn to the young woman, it is channeled through his presence to her. He appears to be projected backwards, flattened against the inside of the surface of the canvas, as if to position him at the threshold between the realm of the viewer and the space of the painting that the woman so comfortably inhabits. His black hat, especially, tends to lie flat on the canvas, annihilating the illusion of representational depth that the rest of the painting so delicately sustains. We do not so much enter this figure's perspective as crowd up behind it (much like the lion's-head finials on the back of his chair), obstructed as much as enlightened in an off-center, over-the-shoulder identification with him. It is as if we were in the place of that "other" consciousness that

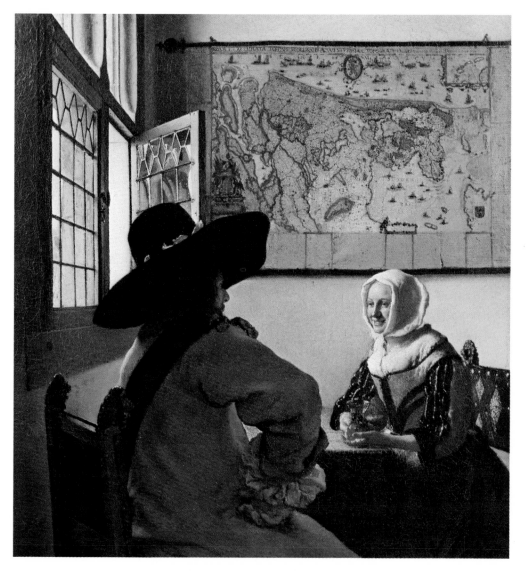

32. Vermeer: *Soldier and Young Girl Smiling*.
19 × 17 in. The Frick Collection, New York

haunts and inhibits the male experience of sexuality ("But at my back I always hear . . .")—as if our point of view were that of the self secretly reflecting on itself, looking at itself looking at its object.[8] The lion's-head finials serve as objective correlatives for this hidden, inhibiting self-consciousness and for its imaginary object as well—they are both id and superego at once—and as such read, by virtue of a paradigmatically overdetermined male psychology, as both a concealed threat to her, a repressed force within him, and what protects her from him by frightening him away, keeping him at a distance.

The emphasis on this viewing position creates a strong perspective divergence, and its distortions in turn affect the way we see the relationship.[9] The woman and the space she inhabits appear to recede from the soldier, while he in turn becomes a dark, looming presence, alien and somewhat threatening to the unsuspecting innocence she embodies. Yet we can see that she perceives nothing sinister about him, and the possibility remains that these negative impressions are merely a function of our angle of regard.

The identification with the soldier encouraged by this perspective, and the mode of self-consciousness it implies, yield anything but immediate self-apprehension: we receive only vague hints of the expression on his face, and are blocked by the protruding arm from the space where his exchange with the young woman takes place. What we have access to instead is the "other side" of the worldly pose he strikes vis-à-vis the woman, and our impressions tend to contradict the careless air it is meant to affect. There is, from where we look, a cramped, defensive ill-at-ease about his presence, and an introverted, evasive quality about his gaze. He fuses the two male figures of *The Procuress*, outwardly resembling the one and inwardly concealing the other.

The gesture of the bent arm and hand, especially, although a perfectly conventional feature of the tavern-scenes of the period,[10] here seems awkward, forced, and psychologically ambivalent. It appears both to turn toward and pull away from the young woman, and either movement can be read as an attempt on the part of the soldier either to open or

close himself to her presence. The suggestion of inner conflict in his posture contrasts markedly with her unguarded openness to him, while his inwardly preoccupied gaze is similarly underscored by her undivided, radiantly focused attention. He even appears to draw back slightly as she leans forward toward him. The palm of his hand that is hidden from her view turns away from her, an unconscious refusal of the gesture she openly (but just as unconsciously) makes to him with hers. And yet his palm *is* open, just as hers is, and one senses how easily they might meet (and how much they would like to), if only the artificially maintained, conventionally masculine posture of the arm were allowed to unwind.[11]

If this over-the-shoulder perspective were the extent of our access to the painting, its atmosphere and mood would be determined, as in the three genre scenes, by those negative, conscience-ridden gestalts that masculinity so often generates through its reflections on its relationship to femininity. Yet where the interiors of *Woman Drinking with a Gentleman* and *Couple with a Glass of Wine* are closed and sullen, that of *Soldier and Young Girl Smiling* is open and radiant. Its problematical elements are contained within a sense of visionary elation.

The deciding factor, of course, is the young woman [33]. Although she is presented in the context of the soldier's attention, his presence casts no shadow upon her, and once we arrive at her she takes on an existence independent of his gaze and the nostalgias that attach to it. She allows us to enter the painting, and find embodiment there, liberated from the projective identification that initially appears to keep us at a distance. (Thus a left-to-right movement similar to *The Procuress*: on the one side, self-consciousness and its distancing, projective mechanisms; on the other, access to woman, to otherness, to the object-world.)[12] Her warmth and openness are truly radiant: they emanate from her, as if she were the painting's inner source, filling the atmosphere of the room, and causing whatever might be dark in the soldier's presence to be cast backward into the space of the viewer. Remote and diminished when seen through the soldier's gaze, she seems to move nearer, both to us and to him, as she comes into her own. As she does so, she opposes and balances the tendency

of the counter-clockwise torque of the soldier's posture to fix the diagonal of the relationship along the lines of a sharply divergent perspective. The very force of her presence seems almost enough to make them equally present to each other, to transform their relationship from a recessive to a stable, lateral one.[13] To the degree that she becomes our focal point, the distance between them seems filled no longer by pathos but by a sense of the imminently possible.

As the young woman becomes an interpretative center in her own right, she returns to us a "triangulated" image of that side of the soldier to which we lack direct access through our unmediated identification with him. An irreversible diagonal of self and other, male and female, is opened (as if by the light source at the apex of their triangularly conceived relationship) to reveal a circulation of aspects. This process, and the changes it makes in our apprehension of the scene, is beautifully described by Berger:

> We read his intentions only in terms of her visible response—the receptive smile and half-open hand, gestures instinctively subdued yet warming to an attentiveness, sympathy, or delight, which is more personal than physical. So mirrored, the officer's motives are, at least for the suspended moment of the painting, purified of their conventional associations.[14]

Mediated through her response to him, he no longer appears to loom over her, and his inwardness takes on a quality more rapt than defensive. The light, which he at first seems merely to obstruct, comes to be associated with the attention he bestows on her, and with her response to his presence. A regressive and self-obscuring mode of self-consciousness is complemented and modified, if not altogether supplanted, by another experience of the self, "seen from without, such as another would see [it], installed in the midst of the visible, occupied in considering it from a certain spot."[15] And this in turn counts as an experience of self-acceptance, a liberation, as if by grace, from the fear and guilt that tend to attach to masculinity's sense of its own sexual presence (before woman, before art).[16]

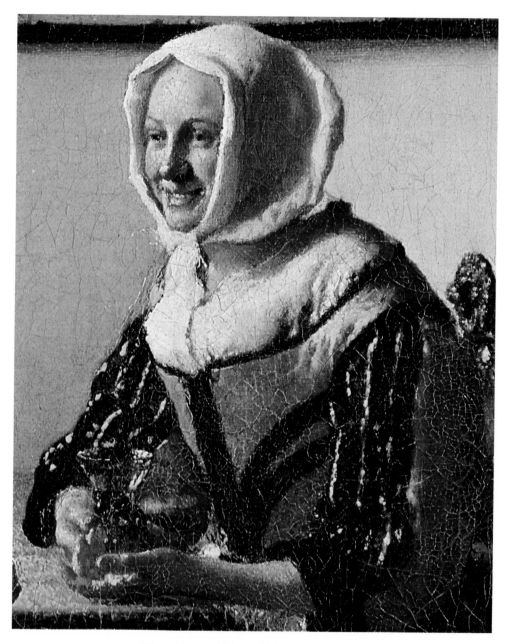

33. *Soldier and Young Girl Smiling* (detail)

Soldier and Young Girl Smiling is also a meditation on male and female horizons, and its vision in this respect anticipates both the problematical focus of the genre scenes and the metaphysical viewpoint of the later paintings. The woman is boxed into her narrow domestic space (the space the painting itself seeks to enclose) by the map, the window, and the soldier-spectator, all representatives of the life of transcendence that is closed to her. Yet fixed within her confines, what she manifests is a unity, a concentration of being, a capacity to exist at the center of the present moment. The outside world in all its guises seems to gather round her as its source, its still point. She more than the soldier seems open to the horizons that present themselves to her.

He, by contrast, seems a peripheral, transitory presence in this context, gazing somewhat timidly across a threshold that some inner conflict makes him hesitant to cross. The superimposition of window, map, and picture plane at the point of his hat would seem to indicate his access to the outer realms that close the young woman in;[17] yet the effect of this detail is curiously negative. The mass and angle of the hat are at cross purposes with the open window, and the flat, uniform black pigment with which it is rendered is similarly hostile to the imaginative, representational urges of both the map and the painting itself.[18] The awareness of external horizons indicated by the intersection of the lines of the map and the window at the place of the soldier's consciousness and point of view is an inhibiting factor here, a point of resistance to the mood of openness and possibility that otherwise characterizes the painting.

All the paradoxical elements of Vermeer's thought concerning the horizons of man and woman vis-à-vis one another are concentrated in the positioning of the map directly over the young woman's head. Goldscheider interprets this detail as signifying that "the country, the whole world is open to her."[19] Berger, on the other hand, finds in it a reminder of the reality that is "conspicuously excluded" from her world.[20] Berger's reading certainly makes more sense of the painting's composition: the map hangs at the back of her head, not before her eyes, and it serves to diminish and lock her more tightly into the space that can properly be

called her own. Yet there remains a certain intuitive rightness about Goldscheider's response. The map, without ceasing to restrict her in one respect, also becomes metaphorically and metonymically attached to her inner life—as if it were an image of what she sees in the soldier, and of the openness and expansiveness that characterize her in that response.

Seen as the background of the soldier's regard, however, the map becomes ambiguous in a different sense. Gowing suggests that "the broad lines of the map . . . [might] add something to our impression of the soldier's bold plan of campaign";[21] yet it can just as easily be taken as an image of his raptness as he surveys the domestic yet intimidatingly intricate and unfamiliar world of woman. In addition, as an image of the world of masculine transcendence ("Politics, warfare, trade—the life of risk and action, the outer world containing the room that contains the map"),[22] it is posed over against the woman in his eyes, as if to suggest the nature of the inner division that makes him hesitate before her. It may also suggest, again in paradigmatically contradictory fashion, that beneath all those exclusively male activities an unacknowledged, evaded preoccupation with woman is to be found.

All of the map's disparate connotations receive equal weight in the painting. They correspond to Vermeer's attempt to come to terms with the vitally overdetermined human moment that is his subject, not so much by internally resolving it as by considering it from every possible angle. An initial experience of having an uncomfortably close emotional involvement in what passes between the couple forced on us from the perspective of the male participant eventually gives way to a sense of a more distant, multifaceted viewpoint encompassing the whole (just as the hexagonal shape of the pictorial space counteracts the strong perspective divergence). And the remarkable thing about the painting is that all its facets cohere at this level, in an integrated, sympathetic act of vision. "Maturity" scarcely does justice to the uncanny, almost otherworldly quality of the understanding and empathy with which human reality is portrayed in *Soldier and Young Girl Smiling*. It has the feeling more of a last than a first work. Indeed, Vermeer's subsequent development would seem

to suggest a compulsion to lose everything that is discovered in this painting, so that eventually it might be found again, transformed. The reappearance of its central relationship and the feelings that surround it, first in the receding background of *Couple Standing at a Virginal*, then later in the stable middle distance of *Artist in His Studio*, assimilated into the act of painting itself, constitutes one of the most profound and enigmatic passages in all of art. It is this development that will be considered in the next chapter.

III

THE ENIGMA OF THE IMAGE

OF THE SOME TWENTY-FIVE PAINTINGS that follow the three genre scenes,
only *The Concert, Couple Standing at a Virginal*, and *Artist in His Studio*
continue to depict the interaction between the sexes. These paintings are
among the most important in Vermeer: they testify to the survival of
the earlier concerns into the later work, and at the same time provide a
reflection on the development that leads away from them. Vermeer's
subject—the attention man pays to woman—remains the same, but there
is a gradual refocusing, so that first the image itself, then the act of
representation come into view, along with the metaphysical issues that
impinge on them. Together these three paintings map the space of the
artist's enterprise, the transcendental coordinates within which his soli-
tary women take shape.

The setting of *The Concert* and *Couple Standing at a Virginal* is still
basically that of the three genre scenes, yet the unresolved tensions and
conflicts that bedevil the earlier paintings seem to have been definitively
laid to rest. The solution appears simple enough: the human content is
banished to the far recesses of the room, beyond the range of the viewer's
powers of appropriation. Yet the result is a new mood of intimacy, a sense
of access to that from which our very nearness alienates us in the genre
scenes. The relationship itself comes into focus, disencumbered of the
artist/viewer's involvement. Suspended gently, tenderly, at the end of
the gaze instead of invaded by it, the moment is revealed as something
whole and complete, in spite of the internal distances that structure it.
And it is situated in a space that for the first time in Vermeer seems
more transcendental than spectatorial. We seem to have (just) crossed
the threshold that beckons to us from the background of *Girl Asleep at
a Table*.

The Concert [34] is by far the more modest of the two paintings. The

realism of the depicted scene is still more or less taken for granted; its self-consciousness, as in the three genre scenes, is limited to questions about the motives of art, about the nature of the artist's involvement in his material. Its themes are in general those of the previous paintings; it differs primarily in establishing a more congenial atmosphere within which to contemplate them. The two pictures on the wall pose the central relationship even more directly than before between the poles of erotic interaction and imaginative solitude (or between the directly sexual and the aesthetically innocent or sublimated: the landscape is to the brothel scene as the background is to the foreground in *Couple with a Glass of Wine* and *Girl Asleep at a Table*, or as the inner circle is to the outer circle in *Gentleman and Girl with Music*); yet the impression now is of balance rather than conflict or tension. Considered in the light of the ironies of the genre pieces, the counterpoint between the painting's own concert trio and the Baburen *Procuress* [35] that hangs to the right of it might be expected to comment sardonically on the restrictions imposed by the bourgeois proprieties so strictly observed within the painting. Yet in this case the contrast is altogether good humored. Indeed, the immobile, introverted quality of the scene creates an imaginatively intensified atmosphere (absorbed from the landscape on the left?) that makes the uninhibitedness of the Baburen seem crass and superficial in comparison.

The change in mood is most evident in the benign treatment of the male figure. He is still a visitor in an interior that obviously favors feminine presence. The two landscapes function as the map does in *Soldier and Young Girl Smiling*, framing his head against an image of the outer world, while enclosing the seated woman even more rigorously within the space of the room. Yet now the structure of the painting conspires to absorb him, and render his intrusive aspect as inconspicuous as possible. The lower part of his body virtually disappears into the ill-defined area beneath the harpsichord. The seat of his chair appears to be empty, and his legs and feet, which upon close inspection can be found propped up against the horizontal bar of the harpsichord support, are replaced by the legs of the harpsichord itself. His head, meanwhile, is whimsically rendered as if it were an object in the landscape that he faces [36].[1]

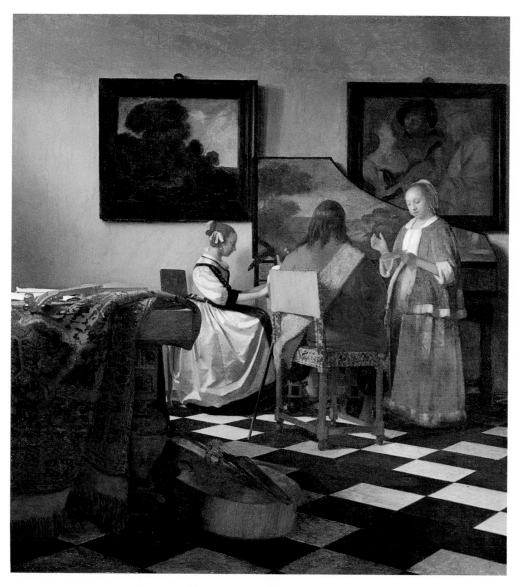

34. Vermeer: *The Concert.*
28 × 24¾ in.
Isabella Stewart Gardner Museum, Boston

35. Theodor van Baburen: *The Procuress.*
40⅛ × 42⅛ in. Museum of Fine Arts, Boston

The intimate centering between two women, one seated, the other standing, recalls the configuration of *Christ in the House of Martha and Mary* [47]; only by now the casual assumption of a dominant presence by the Christ of the earlier painting seems a grossly presumptuous male fantasy, not all that different from the Baburen that decorates the wall of the present scene. Indeed, one facet of *The Concert* is a reflection on the discrepancy between man's artistic representations of his transactions with woman and his actual behavior in her presence. Our sense of the man's ease and unselfconsciousness in *The Concert* hinges not on his dominance but on his anonymity and effacement within the scene. The

84

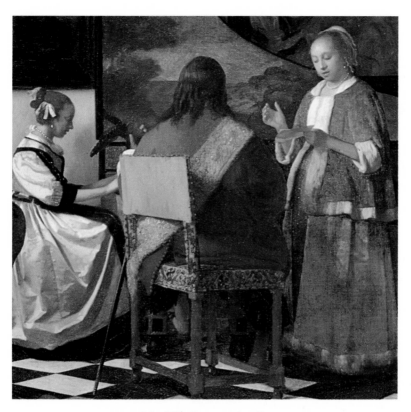

36. *The Concert* (detail)

ideas that receive their initial statement here will be carried to their conclusions in *Artist in His Studio*.

With the acceptance of male presence into the intimate space of the painting, there is a simultaneous acceptance of art itself as an instrument of mediation, even as a medium of fulfillment. Only the barest indication of the man's hand and the guitar it holds is provided, but it is enough to establish a link (of the sort treated sardonically in *Woman Drinking with a Gentleman*) with the woman playing the harpsichord, and to transform what would otherwise have been an image of uneasy attendance into one of relaxed, unselfconscious participation. The closed circle created by the

85

musical occasion is even narrower than in *Gentleman and Girl with Music*, yet the landscape on the lid of the harpsichord provides a spacious, expansive inner horizon upon which the aesthetic sphere of the present work literally opens.

Gone, too, is the bothersome standing position of the man, with its patronizing, paternalistic overtones; an aura of almost childlike innocence enfolds the seated couple, while for the first time in Vermeer the superego finds feminine embodiment, in the rather matronly figure who stands at the right, chaperoning as well as taking part in the musical occasion. Although her presence may inhibit any direct expression of intimacy between the couple (she takes the place of the lion's-head finials of the earlier works), its effect is not so much to increase as to relieve the tension between them. She ballasts as well as presides over their relationship: the gesture of her right hand, which might *almost* be an admonition, turns out instead to be that with which she keeps their time. It is interesting, by the way, that although the seated woman is the heir of the women of the earlier paintings—her dress is that of *Soldier and Young Girl Smiling* and the Dresden *Letter Reader*—it is this standing figure who, inauspicious as her presence here may be, is the prototype of the solitary, bell-shaped women of the masterpieces to follow.

With the act of distancing that *The Concert* performs, the act of seeing and the image itself come into focus, but almost accidentally, inadvertently. In *Couple Standing at a Virginal* [37], on the contrary, they are the essence of the matter. Here it is not merely the artist's motives but reality itself, and the life of the image, that are in question. The table and the viola da gamba of *The Concert* are inert, scarcely focused objects, adjuncts to the human moment whose mood they counterpoint and absorb; but those of *Couple Standing at a Virginal* are *presences*, imbued with a life that exceeds the logic of verisimilitude. In a like manner, it is no longer merely a question of depicting desire; the image itself, the space that the painting does not so much mirror as carve out of thin air, resonates with a desire that is intrinsic to representation, and that finds only partial, tenuous

86

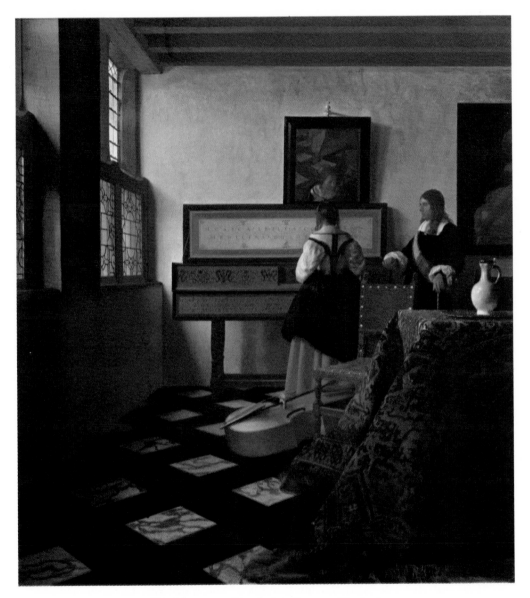

37. Vermeer: *Couple Standing at a Virginal.*
28½ × 24⅝ in. Buckingham Palace, London

embodiment in the human figures depicted within it. It is with this painting that the impulses behind *Head of a Young Girl* and *A View of Delft* become visible in Vermeer.

In terms of human content, *Couple Standing at a Virginal* clarifies the somewhat tentatively achieved resolution of *The Concert* by transposing it back into the more tense, erotically charged atmosphere of the earlier paintings. The objects piled up between the viewer and the couple recall the defensive structures erected in the foregrounds of *Girl Asleep at a Table* and the Dresden *Letter Reader*; yet here they encourage imaginative involvement, and subtly channel it toward the central point of human exchange. The sphinx-like presence of the carpeted table [38] elicits the anthropomorphizing, eroticizing impulses of perception—Gowing identifies its form as that of a seated woman, a perception that tends to be confirmed by the memory of the carpets that serve as imaginative extensions of the women's laps in *The Procuress* and *Girl Asleep at a Table*.[2] The white pitcher seems (unlike its presence in *Woman Drinking with a Gentleman* and *Couple with a Glass of Wine*) an object of and for thought, a still point toward which the mind can reach to steady itself as it enters the imaginative space of the painting. And the empty chair and unused viola da gamba, which are the only explicit signs of the absence that is so strong an element of the painting's mood, nevertheless indicate a place for us in the composition, and invite us to participate in the "musical" interchange between the couple at the virginal.

The accumulation of objects and interlocking forms in the right-hand side of the painting balances the sensation of sharply receding space accentuated on the left. The diagonal leading through the edge of the table and the chair appears to measure a much shorter distance to the woman than the one indicated by the lines of the wall on the left.[3] In addition, the viola da gamba and the edges of the rug cover the tile floor that, if left exposed, would define our relationship to the couple in strongly recessive terms. As it is, it seems but a short distance from the "foot" of the rug (and the lower edge of the painting) to the woman's skirt—a distance measured not so much in depth as vertically, in terms of the forms that lie flat, one above another, on the surface of the canvas.

88

38. *Couple Standing at a Virginal* (detail)

So convincing, in fact, is the impression of spatial integrity conveyed by the broad perspective, that it comes as something of a surprise to notice how radically the painting divides down the middle into two compositionally distinct spaces. The left-hand side might be part of an interior by Saenredam: it gives almost surrealistic emphasis to the deep recessive space of the painting, its existence as "an envelope of quiet air."[4] This emphasis on a third dimension controlled by the viewer's perspective enhances the illusion of a life, a present moment, coterminous with ours, accessible to us on our own terms. As Descargues remarks: "we . . . feel that simply by sitting down on the floor we should find ourselves in the heart of the picture."[5] Yet in the process life, as in *A View of Delft* [4], comes to be seen as something unapproachably remote: we are made to sense the tenuousness of human presence, and to feel the slippage of the moment that holds it in suspension (the light that filters through the windows appears to be changing even as we view it). The right side, on the other hand, calls attention to the painting's existence on the canvas, as "a surface with the absolute embedded flatness of inlay."[6] Here the illusion of depth is minimized; the couple come toward the surface of the canvas, caught and stabilized within a mosaic of interlocking forms. Yet in doing so they acquire, as the life captured in *A Street in Delft* [39], the remoteness of something that exists only on a painted canvas, or in the memory, something already set in the past or fixed in the artifice of eternity.[7] These two visions mesh imperceptibly to bring about, for the first time in Vermeer, that space of metaphysical concern where the greatest of his achievements take place.

Within this intricately measured, dialectically overdetermined space, the separateness of the individual figures becomes more pronounced than in *The Concert*, and the aura of privacy that surrounds them more introverted and reflective. Both the costume and the pose of the woman recall the solitary Dresden *Letter Reader*, while the appearance of the man and his proximity (in terms of the painting's mosaic) to the white pitcher that reappears from *Couple with a Glass of Wine* associate him with the meditative, withdrawn figure in the background of that painting. In bringing

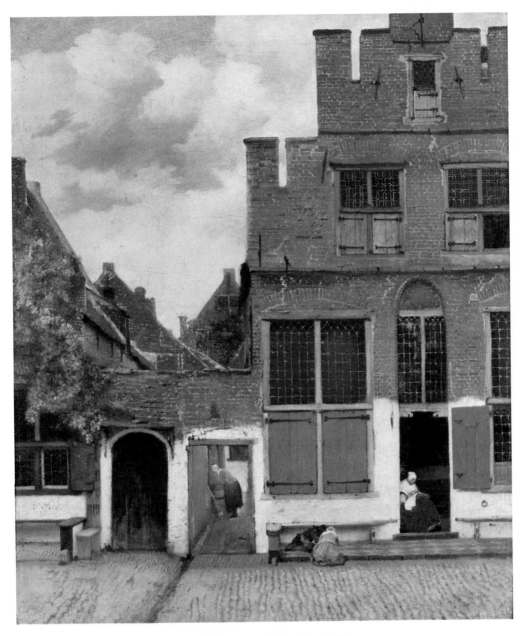

39. Vermeer: *A Street in Delft*.
21¼ × 17¼ in. Rijksmuseum, Amsterdam

these two previous embodiments of the passive, self-absorbed aspects of masculinity and femininity together in an obviously romantic atmosphere (the woman's reflection, which in the Dresden painting reinforces her solitariness, here completes the circuit of desire), Vermeer suggests a solution to the problematic with which all the earlier paintings are concerned.

The man's attendance on the woman likewise becomes subject again to the ambiguities that attach to the presence of the male figures in *Woman Drinking with a Gentleman* and *Gentleman and Girl with Music* (is he her suitor, her instructor, or merely a deferential audience?), yet they no longer implicate the bad conscience of the artist, and as a result they seem irrelevant to the painting's vision of what draws the couple together. The expression on the man's face has been described by one critic (in support of the view that "the painting's subject does not matter") as "indifferent,"[8] and an isolated detail [40] might support an even more negative description. Yet from far away he appears rapt and utterly transfixed, and Vermeer's allegiance in this case is clearly to the truth of the distant view.[9]

One of the magical aspects of the painting, in fact, is the intimate, finely nuanced access that is achieved to the human content of the scene, not only in spite of but as a function of the remote perspective. The woman's "gentle stillness of stature,"[10] especially, with its ambivalent, barely perceptible acknowledgment of the man's presence, elicits an intensely empathetic response from the viewer: the back of her head is as eloquent (its rendering seems contemporaneous with the neck and earlobe of *Head of a Young Girl*) as that of the man in *The Concert* is inexpressive. These romantic impressions, it should be noted, would remain valid even if it could be shown (which of course it cannot) that the woman's stance were merely that of a harpsichord player, and the man's that of a music instructor, and all else merely the effect of the pathos of distance. Vermeer is dealing here, as never before, with the truth as it appears within the artist's vision, and its strangely opportunistic relationship to the accidents and indeterminables of ordinary perception.

Vermeer's preoccupation with thresholds is again evident in his ap-
proach to the "subject" of the painting. The distance that separates the
couple is charged with the same mood of anticipation and restraint that
characterizes the relationship depicted in *Soldier and Young Girl Smiling*.
The right hand that the cavalier of the earlier painting unconsciously
withholds from the woman who faces him now tentatively comes forward
to bridge the gap between them.[11] Yet at the same time the woman's
hands, which in *Soldier and Young Girl Smiling* are so warmly and openly
responsive to the cavalier's presence, become somewhat nervously preoc-
cupied with the keyboard of the virginal, invisible to the viewer and
withheld from the man who attends on her. The instrument of art thus
mediates and stabilizes, as it does in *The Concert*, but it also absorbs and
expresses the inhibitions that create a need for it. The inscription on the
lid of the virginal reads *Musica Letitiae Co(me)s* [or *Co(nsor)s*]—*Medicina
Dolor(is)* [or *Dolor(um)*]: "Music, companion (or consort) of joy, medicine
for pain (or grief),"[12] suggesting an allegory of the pleasure and melan-
choly, not merely of love, as Gowing suggests,[13] but of art itself.

It is ultimately not the virginal, however, but the mirror above it that
mediates the threshold between the couple most decisively, and enables
the final image to suggest something so entirely different from the pathos
of abject or unrequited love. The triangulation effected by the reflection
that secretly gazes at the man is one of the most mysterious passages in all
of Vermeer. The man himself may feel isolated in his desire, but it is
revealed as something that circulates, and unsuspectingly returns to him.
The vision of the painting, instead of stopping at the point of anticipation
and longing, opens on a more radical limit, to reveal, again in Gowing's
words, "the pure essence of relationship."[14]

Yet so little does the image in the mirror agree with the woman whose
presence it reflects, and so powerful is the aura of metaphysical enigma
surrounding it, that one can scarcely be satisfied with a purely logical
account of its effect. It reads more convincingly as a projection of her
inner, otherwise unexpressed aspect than as a straightforward reflection
of her gaze. She seems no more aware of its attention to the man at her

side than he is. And as a revelation of the essence or deep structure of relationship, the image seems to belong as much to the man as to the woman. It pivots about the fulcrum of his subjectivity, as the idea of his desire. The virginal player, as already noted, recalls the solitary Dresden *Letter Reader*; but now it is the *man* over whose shoulder her reflected image hovers, as if her emanation were at the same time his anima, his deeper, second self.

Here Vermeer's own experience within the triangle of representation may be a factor. The position of the mirror vis-à-vis the man's attention to the woman is almost exactly comparable to that of the canvas depicted in *Artist in His Studio* [41] vis-à-vis the painter's rapt focus on the model whose distant, half-averted gaze his brush is in the process of bringing nearer to him. (In *Head of a Young Girl* this other self, this mediating figment of desire, becomes the entire world of the artist/viewer, shorn of any reference to the reality whose evasions engender it.) It is notable in this respect that behind the head in the mirror of *Couple at a Virginal*, the artist's easel (or whatever device occupies its place) is visible. The mirror would thus seem to hold a privileged space where the strict logic of representation is transcended: where the gap between image and reality is elided, and the desire of the artist—to be taken into his work, to share the life of what he paints—is fulfilled. In doing so it provides a tentative gloss on the "faintly magical atmosphere"[15] of *Couple at a Virginal* itself, and at the same time prefigures the world of the more confident masterpieces: not only *Artist in His Studio*, where both artist and model are contained within the painting's frame, but the series of single standing women that includes *Woman Pouring Milk* and *Woman Holding a Balance*, where there is implicit access to a metaphysically enhanced realm of feminine presence.

But in *Couple at a Virginal* the gain is balanced by a sense of loss. What appears in the mirror is vague and insubstantial, and the artist's tenuous presence there involves his absence from the world it reflects. And where exactly *is* this world, whose reality the painting conveys with such visionary (or hallucinatory) force? Is it life itself—that which evades the artist's grasp, and survives (in) the absence of the viewing self? Or is it the

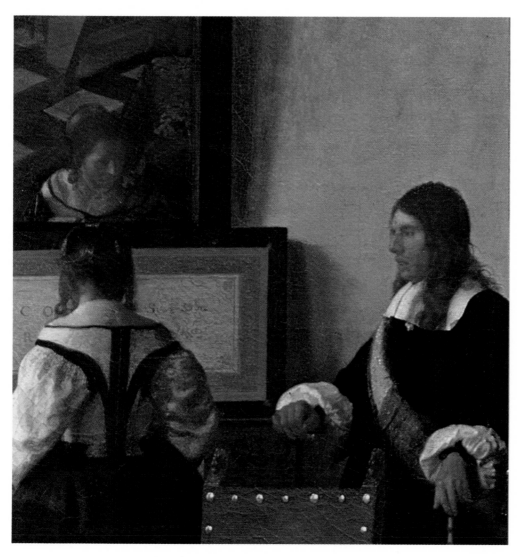

40. *Couple Standing at a Virginal* (detail)

hermetic realm of art, at whose center a ghostly author is installed, busily bringing into being on his invisible canvas the world that contains and confirms his presence?

It is just when art succeeds in capturing life, and not just more art, that life itself is invaded by a sense of the uncanny. Looking at *Couple at a Virginal*, one feels that one understands what Wallace Stevens means by "the world as meditation." The visible world appears to be cradled within an impersonal, disembodied consciousness brooding on the metaphysical themes that impinge on human life and the act of representing it. Crucial to this meditation is the sense of mortality that hangs over the scene (it is the very place from which the artist works), and the vague sorrow that attaches to it. The virginal might for all the world be a casket (the inscription on the lid, so different from the landscapes that decorate Vermeer's other keyboard instruments, has the look of an epitaph), the woman a mourner looking over into it, and the reflection in the mirror a presence gazing back from the other side of life.[16] Yet at the same time, the couple seem to be held tenderly in a space from which all possibility of change or loss has been banished—the giant form in the foreground watches over them as if they were children in a nursery. The sense of a revelation decisive for the artist is in the air, yet its content remains enigmatic. As with *A View of Delft*, the painting can make us feel, depending on our viewing mood, either that we are in the hands of God or that all passes into oblivion, either that the world is there beneath our feet or that nothing exists beyond the moment of perception. No resolution of these contradictory impressions beyond the painting's mode of organizing them seems possible: they are woven into the fabric of life, and go to the heart of the impulse from which art issues, and to which it ultimately returns.

If *Couple Standing at a Virginal* marks the threshold of the world of metaphysical concern upon which Vermeer's middle period opens, *Artist in His Studio* [41, following page 99] invokes its closure. Whether we view the latter as open to its audience (in self-disclosure) or turned meditatively inward (in self-reflection), as penetrating through appearances to the

heart of reality (and discovering there the ongoing act of representation) or as stepping back in order to restore painting to the ordinary world (and in the process identifying the world as the scene of art), it gives the impression of being a final, cumulative gesture, a statement about meaning and value that draws upon all the discoveries embodied in such works as *Woman Pouring Milk*, *A View of Delft*, *Head of a Young Girl*, and *Woman Holding a Balance*.

Less immediately apparent, although perhaps ultimately more revealing, is the intricate network of references within the painting to the earlier scenes of erotically unresolved interaction between men and women. The figure of the artist seems a resolution of all Vermeer's previous images of male discomfiture and restraint. The self-conscious cavalier of *The Procuress* (the hat and costume constitute an obvious allusion) is transformed into an artist blissfully unaware of his audience, anonymously absorbed in his work, profoundly implicated in the exchange of erotic energy and the experience of fulfillment from which artistic consciousness is set apart in the earlier painting. His posture, and especially the back of his head, recall the seated figure of *The Concert*, only now not so much has to be repressed in the way of presence and expression to obtain an image of good conscience (for the first time in Vermeer since *Christ in the House of Martha and Mary*, the lower part of a man's body receives full, even comic representation). The slight turn of the artist's head in the direction of his model becomes unexpectedly moving: although only the barest trace of the gesture is indicated, it seems more expressive of the force that draws man to woman—and keeps him apart from her—than anything we might view on his face. It may be only the "neutral, unimpassioned"[17] gaze of an artist intent only on representational accuracy; yet it reads as an expression of love, even if that love has no existence or meaning outside the act of representation itself. We are back to the paradoxes of Degas' nudes, now profoundly meditated by the work of art in which they appear.

Given the situation as Vermeer has depicted it, we may come to feel that the real function of the painter's art is merely to sanction and prolong his gaze. What seems to count is the feeling the painter betrays

for his model, and the magical atmosphere in which they are held together for the duration of the painting. One wonders by what process, if at all, either of these imponderables will leave their trace on the record of the finished canvas—especially since the painter is in the process of transforming his model into an allegorical figure of Fame or History, a project that could scarcely be more at odds with the values celebrated in the painting that depicts him.[18]

Yet at the same time, what *Artist in His Studio* tends to communicate to its audience before anything else—the painter's lingering over the laurel wreath of his model, and Vermeer's own loving depiction of the tapestry pulled back to reveal the scene bear explicit witness to it—is the sheer pleasure of representation itself, which in some important sense preempts the larger purposes it ostensibly serves. If it strikes us that the act of painting is only a pretext for the relationship it creates between the painter and his model, it seems equally clear that the painter's subject (allegorical, feminine) is only a pretext for the act of painting.

The underlying paradox finds its focal point in the blue leaves of the laurel wreath. Does the painter's concern with copying exactly their intricate pattern (the least virtuosic of painters, he even employs a maulstick at this early phase of his project),[19] and his intent on painting them as blue as they appear on the model's head, merely indicate a single-minded absorption in the business of painting? Is it an aspect of Vermeer's gentle irony that this painter, immersed in a privileged moment of being, confronted by the miracle of the light that streams into his studio and the mystery of the radiant feminine presence that stands before him, remains oblivious to everything but the details of an allegorical prop and the task of transferring them onto his canvas? Or is his brush temporizing more poignantly at the verge of a critical threshold, while he takes his last free look at the face of his model before having to confront it at the level of representation, where all the feelings that look back at the artist from the canvas of *Head of a Young Girl* will come into play?

The painting somehow makes room for both readings, and one of its

most subtle details applies to either: as the painter's brush concentrates on the leaves of the wreath, his hand fills the place that will eventually be taken by the image of the model's face and head—as if it were the raw material out of which her features are to be molded.[20] A narrow strip of white sleeve is even visible at his wrist, just where the strip of white collar appears at the base of the model's neck, and the blousy part of his sleeve lies flat on his canvas, exactly in the place of her stiff, bell-shaped shawl. For just this moment there is bulk and volume, real flesh, where eventually there will only be an image. And it is the flesh of the artist's hand, given to, and one with, that which it paints. It seems appropriate that the laurel wreath over which he labors should crown not the head of the artist but the hand that paints, almost subdued to what it works in.

The leaves of the wreath focus in addition the act of representation itself, and in such a manner as to suggest an enigmatic triangular or circular process subsuming the simple polarity of object and image. For the blue leaves appear not only on the model's head and the artist's canvas but also on the upper portion of the tapestry pulled back to reveal them [46]. There is thus a progression from the thing itself—already in this case an artifice, its leaves the color of imagination rather than reality[21] —to the artist's concern with representational verisimilitude, to a pure *jouissance* of forms. And this progression can just as easily be read in reverse, starting at the leaves on the tapestry and moving from the wreath to the canvas or from the canvas to the wreath. The question of what (if anything) is before or behind representation (or, conversely, appearances) is thus subtly reformulated by the very gesture—the pulling back of the tapestry—that appears to provide an answer to it. If the painter's activity seems straightforwardly to assert art's mimetic subordination to an external, distant reality, it is nevertheless within a painting that he paints, and the tapestry that reveals him implies the existence of an imaginative *Urgrund* within which the forms of the real are already woven. (Against the light that breaks dramatically into the painting from a source outside it, the tapestry contains its own immanent, sourceless light, which plays arbitrarily among its folds.) In a like manner, the painting as a whole may

41. Vermeer: *Artist in His Studio.*
52⅛ × 43¼ in. Kunsthistorisches Museum, Vienna

open on a world that is already there, benignly supporting the human attempt to take imaginative possession of it; yet it also intimates the existence of a transcendental imagination—perhaps merely the artist's reflective self—within which that world is being dreamt.[22]

Artist in His Studio also situates itself by way of more complicated structural allusions to *Soldier and Young Girl Smiling* and *Couple Standing at a Virginal*. The emphatic diagonal along which the central relationship is disposed and the hanging map that serves as its background both recall the arrangement of *Soldier and Young Girl Smiling*. Now, however, the means employed in the earlier painting to stress (at least at first glance) a hierarchical disalignment between the sexes, and an alien, intrusive quality about male presence, are used to establish an impression of integration and equanimity. The lowering of the map, the rotation of the diagonal by ninety degrees, and the increase in distance between the viewer and the male figure over whose shoulder the scene is observed, all seem adjustments calculated to unblock the relationship of the earlier painting, and distribute its conflicting aspects throughout the vast interacting system of forms and presences within which it now is contained. The man's presence no longer blocks the opening through which light enters the space of the painting, and as a result the triangular flow that unites the couple across the linear distance that separates them is now stable and unimpeded. The intervention of the artist's canvas likewise stabilizes the conflicting sensations of nearness and distance in the young girl's presence to the soldier, by triangulating them in terms of the artist's long gaze at his model and his arm's length from the image on his canvas.

Most fascinating of all is the metamorphosis in *Artist in His Studio* of the young girl's triangulation of the soldier's complementary aspects. As in the earlier painting, the artist's gaze directs us to that of his model, and hers in turn returns us, not this time directly to the expression hidden on his face, but to a mask that lies bathed in light on the table next to him [42]. This mask is perhaps the most enigmatic of the metaphoric/metonymic displacements that count for so much in Vermeer's work. Its

appearance is less that of a mask than a face which has achieved the status of pure phenomenological objecthood (its luminosity matches that of the model's book), outside the dialectic of looks and the anxiety of expression. The expressive visage, in an art so compulsively self-effacing (and so avid for expression) as Vermeer's, *is* a mask, which can only be revealed in the act of discarding it. And what the artist thereby expresses of himself is only revealed in his absence from the visible, the visible which *is* his absence. The face on the table, even though there is something hauntingly personal about it, is that of neither the painter who painted the painting nor the painter depicted within it but (in Klee's sense) the face of the painting itself—that authorial presence, diffused throughout the whole, for which we have only the evasive terms "mood" and "atmosphere." What can be seen expressed on this face/mask (and felt within the painting) is the access of grace—an acceptance, beyond resignation, of both visibility and death (it reads more convincingly as a death mask than as an emblem of Comedy or Tragedy). It is the antithesis of the authorial face implied by *Head of a Young Girl*.

The map on the wall similarly minimizes the distinctions its counterpart in *Soldier and Young Girl Smiling* helps to reinforce. Instead of emphasizing boundaries and difference, and stressing the division between the domestic space of woman and the worldly consciousness of man, it now serves as a common, homogeneous background in terms of which the model's ever so slight ascendancy over the artist is measured. (It is a map of the seventeen United Provinces before the war with Spain and the current division of the country into North and South.) It is a visible emblem for the background of metaphysical concern—with the experience of being in a world, with the passage of time, with representation, with the dialectic of location and view—that encompasses both sexes and links them across their respective spaces.

The flat black of the artist's hat slices through this background exactly like the soldier's in *Soldier and Young Girl Smiling*. Yet here again Vermeer now seems to be more interested in metaphysics than in sexual identity:[23] it becomes an apt emblem—ironically, in this most reflexive of

42. *Artist in His Studio* (detail)

paintings—for the blind spot at the back of vision and consciousness, the unrepresentable void upon which thought and reflection rest. (There is thus a dialectical opposition between it and the stolid, emphatically grounded body that houses the artist's activity). The presence of the artist—at least of his intentions, his authorial self—within his work is rather ignobly defined as a hole in its fabric, the one place in the image where the magic of representation refuses to "take." There is an obvious and good-humored irony between it and the laurel wreath that crowns the model's head.

And though the artist's hat marks an absence, a place of oblivion precisely where his vision intersects the field of external, historical reality, the top of his easel locates a privileged area in that field, and takes on the appearance of a perspective, a veritable ladder for transcending into it [43]. These details again correspond to the double irony of the painting as a whole: if the painter's concern with Fame and History paradoxically involves a withdrawal into the privacy and isolation of his studio and an anonymous, solipsistic absorption in the pleasures of painting, his activity nevertheless situates him near the metaphysical heart of things, and involves a desire to experience the where and the when, the here and the now of the world at a level that historians and mapmakers can only presuppose.

As far as the spatial and atmospheric "feel" of *Artist in His Studio* is concerned, its most insistent links are with *Couple Standing at a Virginal*. It is in terms of this painting, above all, that *Artist in His Studio* seems to measure its achievement. The emphasis on the *cubicle* of space encompassed by the picture frame (the beamed ceiling amounts to an explicit allusion), the luminous atmosphere, the magical silence, the "presence of a certain hermetic, obsessive, even bewitched element in its adherence to reality,"[24] the sense of a disembodied consciousness brooding over the whole, all work to situate the artist and his model within the same space of concern that the couple of the earlier painting occupy.

There is a strong sense of continuity, moreover, between the relationships themselves. Beyond the plainly visible resemblances—the black

43. *Artist in His Studio* (detail)

105

and white of the artist's costume, his rapt, poised stillness before the object of his attention; the curls, the downturned gaze, the two-tiered dress of the model, the ambivalent torque with which she responds to the artist's presence—it is largely a matter of intangibles that are the essence of both paintings: the same hypnotic attraction, the same erotic charge in the space between the couple, drawing them together and at the same time keeping them apart,[25] the same enhanced sense of the moment in which the relationship is eternally suspended, the same sense of time flowing steadily past it.

Given these similarities, what perhaps most immediately strikes one as different about the two paintings is the sense of relaxation that characterizes *Artist in His Studio*. The tension of the earlier painting disappears, yet the intensity it generates remains, is even enhanced. The space of the painting is ordered even more rigorously than in *Couple at a Virginal*, yet now a benign randomness comes into play: there is a consoling sense of things falling as if by chance into their natural resting places, happy in just happening to be where they are—as if the means by which the man's hand reaches the woman's breast in *The Procuress* had by the time of *Artist in His Studio* become the governing principle of Vermeer's entire universe. The composition of the whole seems to have settled into time, and gravity. We feel it both in the seated position of the artist and in the repose of the discarded mask, which in some strange way has taken the place of the upright, vigilant pitcher of *Couple at a Virginal*. Yet *contra* Simone Weil, the result is a lightening, an influx of grace, a dispelling of whatever it is that still burdens the atmosphere of the earlier painting.

This vision of order as something simply, randomly given, as something that takes care of itself and whatever manages to find its way into it, not only frees consciousness (especially artistic consciousness), but generates an air of permissiveness that extends to the central relationship itself. For the first time in Vermeer's treatment of the transactions between the sexes, no superego figure, not even the benignly feminine variety of *The Concert* and *Couple at a Virginal*, appears within the painting; the man is finally free to look, and the woman to openly constitute herself as an erotic object in his gaze.

An equally important term for characterizing the passage from *Couple at a Virginal* to *Artist in His Studio* is integration. It applies to all aspects of the painting, from the depiction of the figures within it to our own inner experience as we stand before it. The two incongruous aspects of the woman in the earlier painting—the still, bell-shaped body with its subtle torque, and the gaze in the mirror lit from the left by the entering light, turned down and toward the attendant male—are united in the figure of the artist's model. The suitor and the painter whose presence is implied by the mirror of the earlier painting are likewise fused in the figure of the artist himself. Their relationship is brought forward into the functional heart of the painting, and involved in a symbiotic give-and-take with its setting. The vertical folds of the model's lower skirt, for instance, appear to support the table (an effect enhanced by the way the table's own support is obscured by shadows, and tends to merge with the cloth that hangs limply over it), and they in turn gain a certain impersonal weight and monumentality from it.

Especially crucial to this overall sense of integration is the elaboration of the triangularity of the earlier couple's relationship. The bracketing of the artist between his model and the image taking shape on his canvas has already been mentioned; balancing this triangle is another one on the left involving the mask, and similarly transforming the triangle of the earlier painting. Now it is the artist whose face we do not directly glimpse, and he looks counterclockwise instead of clockwise in the direction of his model, whose face is now visible to us; she in turn appears, as before, to look away from him, but her line of sight leads us to a deflected, displaced "image" of his face, which rests in her gaze (or at least in the light associated with it), unnoticed by the artist himself. There is thus ultimately in *Artist in His Studio* a circulation of aspects across four terms, not three: from the model to the mask to the artist to the image on his canvas, with the diagonal between the artist and his model being crossed by an equally crucial if more enigmatic one between the mask on the table and the image on the canvas. These vectors no longer take place in a narrowly circumscribed area in the recesses of a space that in no essential way requires them; they are the scaffolding upon which the structure of the whole is built.

Equally important is the way the contrasting spatial sensations of *Couple at a Virginal* are fused in *Artist in His Studio*. The luminous "envelope of quiet air" now extends across the entire frame, and the accessories of the room are distributed evenly throughout it, all in their separate places, equally endowed with ontological weight and value. Yet it is the overlapping and interlocking of these objects on the surface of the canvas that imparts equilibrium and coherence to the three-dimensional space in which they reside. The hanging chandelier is effectively held in place not by its actual and almost imperceptible attachment to the ceiling in real space—seen strictly as an object in three-dimensional space, it appears to be a strange winged contrivance hovering in mid-air somewhere in the near foreground [44]—but by its place in the mosaic of the painting, where its function is to hold up the map (which similarly receives greater support here than from the two small nails it realistically hangs from) and bridge the gap between it and the flat, horizontal stripes that signify the beams of the ceiling.

In a like manner, what keeps the heavy tapestry pulled back from the scene it reveals is not so much the chair upon which it is draped as the edge of the canvas that intersects it. The tapestry itself, meanwhile, overlaps the heavy end of the model's trumpet just enough to keep it balanced lightly in her hand, in spite of the distance of her grip from its apparent center of gravity. The open copybook hangs carelessly over the table, yet the random position into which it falls precisely bridges the gaps on the surface of the canvas between both the table and the painter and the painter and his model. It is just one of the purely linear devices by which Vermeer ties together the four-cornered relationship at the heart of the painting, and captures the empty space within it.

The interlocking of forms on different vertical planes functions similarly with respect to the painting as a whole. The tip of the painter's maulstick overlaps his canvas, and in the process is assimilated by the map and its isolated patches of red. More important is the diagonal of the tapestry: as it proceeds up the canvas, it links a series of objects—the chair, the fabric on the table, the upright book, the trumpet, the map—that mark intervals along the diagonal leading from the foreground to the

44. *Artist in His Studio* (detail)

background of the painting. Tracing the edges of the right-angle triangle formed by the table, the map, and the diagonal of the tapestry should be as disconcerting as doing the same thing with a form in an Escher print; yet the effect instead is an intuitively satisfying fusion of the two logically discontinuous dimensions of the painting (flat surface and illusionistic space), a reinforcement rather than a subversion of its magically convincing "reality."

The almost ostentatiously willed or contrived nature of these overlappings has the effect of raising them to consciousness. As so often in Vermeer, what in another painter would remain purely a matter of style

becomes an essential aspect of the painting's metaphysical statement. In this case it has to do with a unity between the world as given and as structured by perception, as perceived and as reconstructed by desire. Perhaps no other painting so knowingly reveals to us "the complexity, the intricacy of the spiritual and emotional webbing under the simple state of peace which is its own [and reality's] homeostatic condition,"[26] while managing to leave that condition so blissfully intact.

This aspect of *Artist in His Studio*'s achievement is illuminated by the "failure" of Vermeer's least popular painting, *Allegory of the New Testament* [45]. Several details of the latter suggest that it is meant to be considered in relation to the former: the larger-than-usual dimensions, the tapestry pulled back on the left and unconvincingly propped against a chair, the identically rendered beamed ceiling, the glass sphere that hangs from it, overlapping the frame of the painting that takes up so much of the rear wall. Certainly both the simple homeostasis of *Artist in His Studio* and the intricate spiritual and emotional webbing that underlie it are precisely what is missing from *Allegory of the New Testament*. And its lifelessness is in such pointed contrast to the life of *Artist in His Studio* that intention rather than miscalculation seems the more likely explanation for it.[27] The tapestry of *Artist* conceals a radiant, transfiguring light source; that of *Allegory* only dead, empty space—the source, perhaps, of the spiritual void that pervades the interior as a whole. The *presence* of the model in *Artist* shines through the pose in which the artist has placed her, redeeming his simplistic concept; the *posturing* of the woman in *Allegory* (what is it that makes us suspect she is the patron of the painting?) undermines the integrity of the allegory in which she takes part.[28] In *Artist* there is elaborate dialectical interaction between the three levels of reality represented by the tapestry, the middle ground of the artist and his model, and the map in the background; the three corresponding levels in *Allegory* could not be more absurdly disparate. In spite of the obvious counterpoint between the crucifixion in the background and the content of the allegory being represented in the middle ground, what is most apparent is the lack of relation between the hyperrealism and conspicuous bour-

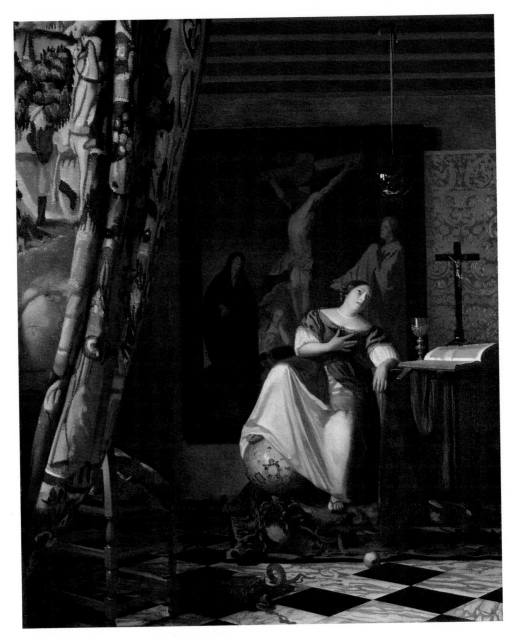

45. Vermeer: *Allegory of the New Testament.*
44½ × 34¾ in. The Metropolitan Museum, New York

geois materialism of the one and the monumental (yet flat, representationally remote) spirituality of the other.[29] The tapestry, meanwhile, encloses a realm of brightly lit pastoral artifice that provides a welcome escape (but no more than that) from the ponderous religiosity that oppresses the rest of the painting. The two figures within it enjoy a precious freedom of movement, and they use it to walk happily away from the frozen tableaus and iconographically fixed gestures that the tapestry itself is pulled back to reveal.

Most telling of all is the different status objects are accorded in the two paintings. The spiritual meanings arbitrarily attached to the objects in *Allegory*[30] paradoxically rob them of the intrinsic spirituality that objects possess in *Artist*; they testify not, as in the latter painting, to a realm of immanent value, nor even, as their own allegory would have it, to the existence of things hoped for and unseen, but to the presence of a materialistic, object-ridden culture.[31] And their function as elements in an allegorical schema isolates them, in spite of the elaborate formal correspondences within the painting, from any *spiritual* interaction with one another—from that "visible sharing of essence"[32] that is the secret of *Artist in His Studio*'s world. The contrast between the transparent glass sphere that hangs from the ceiling and the marble slab that crushes the life out of the snake on the floor is a grotesque parody of the subtle interplay between things heavy and light, rising and falling, suspended and at rest that underlies the homeostasis of *Artist in His Studio*. The deadening effect of *Allegory*, the sense in it of a negation of what is most positive and sustaining elsewhere in Vermeer, gives the impression of having to do with both the painting's allegorical method and the cultural and religious values it serves. While it would be misleading to characterize the vision of *Artist in His Studio* as anti-Christian, its embrace of the perfect adequacy of the immanently given, of a world folded peacefully, self-sufficiently in upon itself, could scarcely be more at odds with the doctrine that *Allegory of the New Testament* expresses.

The integration of the separate facets of aesthetic space that *Artist in His Studio* performs with respect to *Couple Standing at a Virginal* extends to

the "fourth dimension" toward which representation aspires in the earlier work. Now the painter is openly admitted into the painting, which he shares with the object of his vision, as if in fulfillment of the dream of art dimly glimpsed in the mirror of *Couple at a Virginal*. In coinciding with this space, however, *Artist in His Studio* at the same time demystifies it: we discover it not on the other side of a metaphysical threshold but in the artist's own studio, and in the duration that encompasses him while he paints.

It is clearly not where the act of painting arrives, nor what issues from it (the painter's own allegory notwithstanding) but the painter's experience within it that matters here. The sense of fulfillment is focused most resonantly in the almost comic image of the artist *seated* before his canvas, both feet planted on the floor. (His drooping stockings defy comment, yet they are touchstones for the painting as a whole.) It is not fame, and certainly not dignity, that the act of painting bestows upon the artist—rather a confirmation of his own mundane existence, the experience, lost to thought and desire, of physically belonging to a world that is physically present to him. Art, here, seeks to quiet desire not so much by achieving its aims as by restoring within it what was lost with its advent—unity of being, the immanence of the world. (And the painting is fully aware that there may really be nothing "before" art or desire, that the world of immanence itself takes shape within a frame.) The painter's eyes look while his hand paints, as if external reality flowed directly through him onto his canvas, unimpeded by reflection.[33] In the moment the painting captures for us, he inhabits his desire, is at home within it, and as such it seems something that might last forever, as its own fulfillment.

Yet against the depicted artist's absorption in an unproblematical, context-free beginning, oblivious to the pressure of ends and consequences, there is the sense of closure, of cumulative arrival, even of mortality, evoked by the painting that depicts him. And against the painting's celebration of the artist's experience within the creative process, there is its own ruthlessly finished nature, its perfection of an impersonal style intent on leaving behind not so much as a brushstroke to

betray its secrets. It seems impossible that Vermeer could have gone about painting *Artist in His Studio* in the "stolid, ingenuous manner"[34] of his surrogate; yet so complete and inevitable is the interlocking of his forms, so equal is the value given to every inch of his canvas, that any other beginning seems almost equally implausible. In spite of the painting's striving for visual accuracy, one cannot imagine what was before Vermeer's eyes as he painted it.

Nor are we allowed to take the painting seriously as literal self-representation. There is even a sense in which *Artist in His Studio*, while seeming to fulfill the mirror image of *Couple at a Virginal*, is actually the painting in which Vermeer most radically accepts his absence from the scene of representation. Painting an artist into the work may be the most effective way of painting himself out of it. The depicted artist's assimilation into the space of the painting is so complete that an aura of metaphysical apartness insulates him from direct connection with anything in the realm "outside" the painting. His untroubled presence there seems the outcome of a relinquishment of the active by the reflective self, and of the image by its author. Anything like a mirror effect or a sense of infinite regress is precisely what the painting's renunciations allow it to avoid. In spite of the complexity of its vision, it is as reassuring to look at as Velasquez's *Las Meninas* [67] is disconcerting.

The painting's gestures in the direction of self-representation are further undermined by its ironical treatment of authorial status. Only a fog of reddish-brown hair and a hand that looks like a blob of unformed flesh serve to indicate the existence of the person beneath the fantastical costume.[35] The comic attitude suggests a benign but radical distance: Vermeer seems to look upon his surrogate as a pure fiction rather than a mirror image. And yet it is obviously a cherished fiction, perhaps the one at the heart of his work. The sense of authorial investment in an image is as powerful here as in any of Rembrandt's self-portraits.

The contrast between the painting's comprehensiveness and intricacy of vision and the depicted artist's narrowness of focus works in much the same way. The scene of painting is as vulnerable to the peripheral

awareness that circumscribes it as the idyllic moment at the center of *Gentleman and Girl at Music* is to the outer circle of reflection that hedges it in. The miracle of *Artist in His Studio*—its *grace*—is that the affirmations implicit in the naiveté with which the depicted artist is able to begin, and go about his business, are not subverted by this encircling, problematizing consciousness. Nor does the latter find itself alienated or excluded. The objects on the periphery (the map, the mask on the table) and the implications they carry must no longer, as in the earlier painting, be kept at a distance, outside the sphere of the central relationship; they are integrated into its very structure, if not into the consciousnesses of the individuals within it. It is likewise for the specific presence of the artist/ viewer: instead of rejecting him by coolly insisting on his visibility, the painting now pulls back its tapestry as if precisely for his benefit, and even provides a chair for his invisible presence to the scene—in a place that is reserved for him *as* viewer, not as someone still driven by a nostalgia for vicarious participation.

Lucidity has been defined as "the refusal of adequate images."[36] The consoling power of *Artist in His Studio* lies to a large degree in its transcendence of this definition. It is able to take that last precious step beyond lucidity into the act (and the ethic) of creation. In it the ironical distance between (self-)consciousness and its (self-)representations is transformed into a regard for the life of the image and the creatures who have their existence within it. The problematical awareness remains, but the self is forgotten in authorial concern. The artist and his model take root in an eternal present, but a relinquishment, a death intrinsic to creation (the mask resting on the table is its visible emblem) is the medium in which they survive.

There *is*, then, about *Artist in His Studio* a sense of the "adequacy" of the *image* (but "adequate" to what? the obscurity in the definition catches exactly what is elusive in Vermeer's vision)—a sense of the desire that generates art finding its embodiment in what is painted on the canvas, but more by way of bemusedly accepting than passionately achieving it. In these respects the painting is again the antithesis of *Head of a Young Girl*,

and within the problematic they articulate between them, one can never be sure which has the last word. Nor can one be certain about the nature of the dialectic that unites them. The phrase from Nietzsche that so hauntingly articulates the mood of *Head of a Young Girl*—"that an image may not remain merely an image"—seems no longer to apply to *Artist in His Studio*, where painting seems either to have relinquished or been released from the desire to transcend its own conditions. Yet the conditions that Nietzsche proposes for the fulfillment of that desire are as beautiful an expression as one could imagine of the authorial atmosphere in which *Artist in His Studio* reposes:

> Where is innocence? Where there is will to begetting. And for me, he who wants to create beyond himself has the purest will.
> Where is beauty? Where I *have to will* with all my will; where I want to love and perish, that an image may not remain merely an image.

Perhaps the problem is with that phrase *"merely* an image." After everything has been said about Vermeer, it will be the enigma with which his art continues to tease us.

46. *Artist in His Studio* (detail)

EPILOGUE:
MEANING
IN VERMEER

In ways that I do not pretend
to understand fully, painting deals
with the only issues that seem to me
to count in our benighted time—
freedom, autonomy, fairness, love.

ANDREW FORGE, "Painting
and the Struggle for the Whole Self"[1]

"WE HAVE BEGUN TO SEE," a recent study of Vermeer informs us, "that seventeenth-century Dutchmen looked at pictures, and at reality, rather differently than we do."[2] What we take to be realistic, affectionately depicted scenes of everyday bourgeois life turn out to have been for their original audience dense with emblematic significance and didactic intent: "A large body of pictures-with-comments, especially prints with inscriptions and emblem books, suggests that many images were both to be enjoyed and to be pondered for the lessons they had to teach. The Dutch had a taste for moralizing that we struggle to imagine today."[3]

Regardless of all that is problematical about the historical reconstructions involved in this iconographical approach, there is no denying that it has yielded genuine and important insights into the work of Vermeer's contemporaries;[4] but when it is applied to Vermeer himself, the work of elucidation seems capable only of disfiguring the painting in question. Witness the conclusion drawn by a study entitled "Vermeer's *Girl Asleep*: A Moral Emblem":

> The young woman personifies Sloth, the vice that opens the gate to all the other vices, symbols of which surround her. . . . The apples on the table are attributes of Aphrodite, goddess of love, as are the pearl earrings the girl wears. The apples refer also to the Fall of Man and Original Sin. Fruits, as well as handsome pottery, glassware, and silver utensils, are typical symbols of the vanity of worldly satisfactions. . . . The message of the painting is: Let us be alert to avoid the snares of sensual pleasures. All worldly satisfactions are but vanity. The freedom of our will makes each one of us responsible for renouncing the earthly in favor of divine truth.[5]

The problem, clearly, is that the method exemplified here takes all too readily to the sort of moralizing that we supposedly must struggle to imagine in the unfortunate seventeenth-century Dutchman. The responses it generates are so obviously ill-equipped to deal with what distinguishes Vermeer, so remote from what any normal viewer might think to say about him, that it might seem best left to its own devices,

were not its findings *and* its assumptions already being assimilated into the anonymous body of commonly accepted knowledge about the artist. It is bad enough when a contextually oriented study is hailed as "the long-awaited demystification" of Vermeer,[6] but even worse when the unsuspecting purchaser of the UNESCO collection of slides of his paintings is informed matter-of-factly, and without further elaboration, that the instances of women receiving, reading, or writing letters "are, beyond a shadow of a doubt, allusions to requited or unrequited love," and that both *Woman Putting on Pearls* and *Woman Holding a Balance* have "an emblematic content," that of the former being " 'vanity,' " that of the latter, " 'the brevity of life.' "[7] Such accounts are so destructive of what in Vermeer does constitute meaning, and what is asserted there in the way of value, that some purpose might be served by attempting to indicate what is inappropriate about them, as well as what it is in Vermeer to which they are responding.

Christ in the House of Martha and Mary [47], probably Vermeer's earliest extant painting, exemplifies in exceptionally pure form the subversive thrust of his relationship to the iconographic practices of his contemporaries. The biblical anecdote upon which the painting is based[8] was a common subject for seventeenth-century painters, and it is obvious from internal evidence that Vermeer was aware of the tradition.[9] The nature and extent of his departure from it, however, can be gauged by the inadequacy of a strictly anecdotal reading of the painting: "Martha, who thinks she is doing her duty to Christ by bustling about, pauses for a moment at the table; Mary, who ignores the housework in order to listen, sits in rapt attention; and Christ, explaining that 'Mary has chosen the better part,' links the two women with his gaze and broad gesture."[10] This account reintroduces into the painting precisely what has been excluded from it. Vermeer has completely suppressed the narrative context, and the visual information he does provide neutralizes the judgment that is the point of the original story.[11] His Martha does not "bustle about," nor is there the slightest hint of "dutifulness" about her behavior. She is, if anything, even more raptly, radiantly attentive than Mary, and her

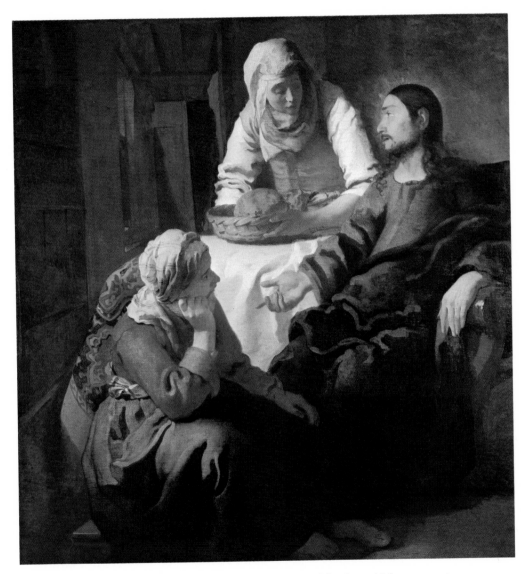

47. Vermeer: *Christ in the House of Martha and Mary.*
62⅛ × 55½ in. The National Gallery of Scotland, Edinburgh

gesture reads as an offering in which her entire being is invested. It is clearly a dialectic within feminine being that Vermeer is interested in, and not a moral distinction between two chosen ways of life. Christ's presence serves *merely* to link the poles of this dialectic—as, indeed, his presence serves merely to evoke them. The values embraced in this painting are ontological, and they are predicated on a refusal of moral judgment.

Girl Asleep at a Table [23] provides a more complex example of Vermeer's strategy of choosing a genre motif with a long history and a rich accumulation of meaning,[12] only to place it in a context that demands a purely intrinsic reading of the image. Comparison with Maes's *The Idle Servant* [48] clearly demonstrates the process of exclusion upon which Vermeer's uniqueness, especially in the early work, is founded.[13] Maes is at great pains to explain his painting to the viewer: the composition locates the main space of the painting, making it clear that the young woman is a servant; the details that surround her announce the theme of idleness and its consequences; and the older woman who stands beside her even indicates to us the form our response to her is supposed to take.

Vermeer, on the other hand, conspicuously abjures all such explanatory gestures. He insists instead on a direct imaginative relationship between viewer and subject, unmediated by anything save the dynamics of the aesthetic response—which, as a result, tends itself to become the subject of the painting. The emblematic-looking objects that he does include intensify rather than explain away the enigmatic atmosphere; they testify to the presence of significance, but otherwise remain as mute and dense as those in most Dutch paintings are transparently expressive. Even the painting on the wall is there more as the sign of a private obsession than of a publicly accessible meaning. All we see is a mask and part of a naked leg; if we are able to infer the presence of a Cupid from the painter's subsequent work (the same painting appears in *Gentleman and Girl with Music* and *Woman Standing at a Virginal*, each time more plainly visible), we are only drawn that much further into the hermetic inwardness, into the purely authorial preoccupations of the painting.

In addition, the girl herself is rendered, as we have already seen, in a way that prevents a straightforward moral or psychological reading of the

48. Nicholaes Maes: *The Idle Servant.*
27½ × 20¾ in. The National Gallery, London

painting. The expression on her faces changes from sorrow to well-being and back again before one's eyes [49]. Her pose suggests sleep, or at least abandonment to some inner event, be it grief, desire, or fantasy; but the hand that rests lightly on the table (it appears to be Vermeer's own addition to the inherited motif) functions as a sign of conscious poise, a delicate reassurance of the continued presence of the world, and the self's presence to it. And what can be read as an image of Idleness or Sloth tends to be even more persuasive as a concentration, an intensification of being, accomplished in uniquely feminine terms—a state of grace beyond the

reach of the will, and not a state of moral disarray that reigns in the will's absence.

The difficulty in objectively interpreting her presence forces us to relate to it at a more primordial level. We experience a mirroring that reaches back behind subjectivity: the painting seems to open onto an image, a complement, of the desire that draws us to paintings, and is nourished by our gazing on them. Whatever meanings exist in *Girl Asleep at a Table* are intrinsic to aesthetic experience, and they come into their own when the distances that moral and psychological understanding impose fall away.

The stakes in this argument become much greater when it comes to *Woman Putting on Pearls* and *Woman Holding a Balance*, the paintings by Vermeer (outside *Artist in His Studio* and *Allegory of the New Testament*) most often subjected to an emblematic reading. In these two works the theme most intimately Vermeer's own, that of a single, free-standing woman, comes to fruition, and the values inherent in it receive their most confident, fully articulate expression. "Epiphany" may be too violent a term for the gentle stillness of these paintings, yet here, if anywhere, the meaning of life, its affirmative core, is surely revealed. To perceive them as embodying puerile moral lessons that warn against the enticements of worldly pleasure is to mistake the essence of Vermeer.

Yet it is just such an interpretation that has come to be the rule when commentators take up the "meaning" of these paintings. The following gloss on *Woman Putting on Pearls* [50] is typical, not only of the approach but of the confusions that result when a need is felt to reconcile it with the obvious sensual pleasure the paintings afford:

> Light streaming into the room gives a warm radiance to the broad space between the woman and the mirror she is looking at, and heightens our sense of the woman's pleasure with her own image. Again we might ask why Vermeer chose this subject. Because it was beautiful, familiar, psychologically interesting? Yet, but another motive must have been the powerful associations attached

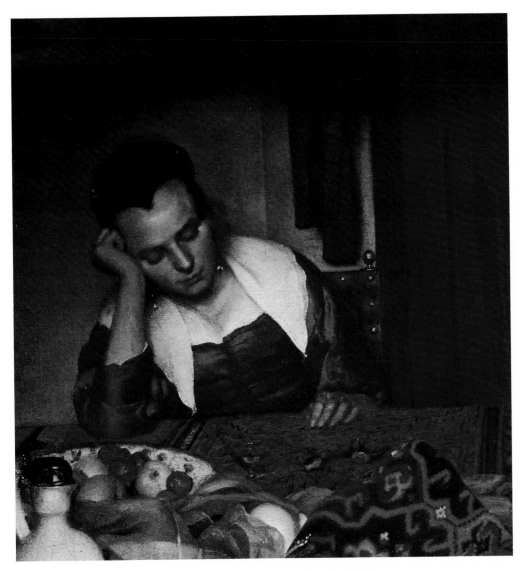

49. *Girl Asleep at a Table* (detail of 23)

to images of women adorning themselves. Two centuries before, when Bosch needed someone to personify Superbia (Pride), one of the Seven Deadly Sins, he chose a woman in a well-appointed house dressing herself and looking in a mirror held by the devil. A beautiful woman with pearls and a mirror became one of the commonest embodiments of Vanitas, sinful preoccupation with worldly things, against which we have constant warnings in Dutch art. As the seventeenth century wore on, the trend in genre painting was away from elaborate symbolic apparatus and toward reduced, less obvious, and sometimes cleverly disguised symbolism. But even when the traditional allusions to Vanitas are few, as in the paintings by Terborch and Vermeer, we should assume that they were recognized and understood in their time.

While most people will admit that Vermeer portrayed a situation associated with Vanitas, some have found it hard to believe that he really intended a warning to his audience or that his picture had a moral purpose. It has been suggested that Vermeer merely took over visual traditions for purely aesthetic ends or that the meanings attached to these traditions had dropped away by Vermeer's time. But there is ample evidence that pictures were "read" all through the century, and some of Vermeer's own works demonstrate that he had a taste for the metaphorical, even the arcane; why not recognize the intellectual force of pictures as well as their beauty? His Woman Putting on Pearls is a masterpiece of concentration: a few key elements of traditional Vanitas imagery and the poetry of Vermeer's light and color combine in an image of worldly pleasure that is wonderfully seductive. As so often in Dutch art, the celebration and the warning are one.[14]

This reading is correct, I think, in claiming that *Woman Putting on Pearls* invokes the tradition of Vanitas; what it fails to appreciate is how radically the painting *opposes* that tradition, and how radical a transvaluation it accomplishes with respect to it. Out of the iconography of Vanity Vermeer has fashioned an image of great purity and innocence, and he tenderly cherishes it as such. The moment of happiness at the

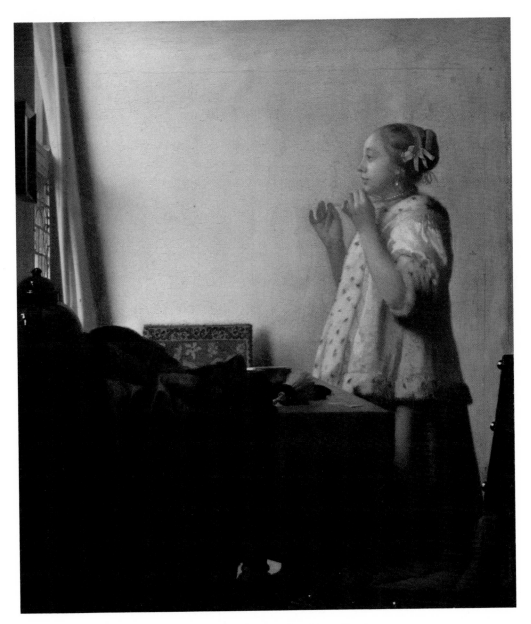

50. Vermeer: *Woman Putting on Pearls*.
21⅝ × 17¾ in. Staatliche Gemäldegalerie, Berlin-Dahlem

129

heart of the painting is characterized by an almost complete absence of ego. The woman appears not to be so much admiring the pearls in the mirror as selflessly, even reverently, offering them up to the light: it is as if we were present at a marriage. Her pleasure is centripetal rather than centrifugal: it has less to do with what she sees in the mirror than with the radiance that comes streaming in through the window to envelop her, bestowing visibility upon her almost as an act of love. In juxtaposing the window and the mirror, Vermeer actually manages to fuse these two experiences, so as to present us with the spectacle of a gaze that circulates, and is returned to its origin, enriched and fulfilled, by the world upon which it opens. Or in the words of Adrian Stokes: "An outward showing goes within."[15] Certainly the distance between vision and its object, or the self and its image, defined as it is by one of Vermeer's most spacious and luminous rear walls, has never been more at peace with itself, less fixated or alienated, than it is here.

The experience depicted within the painting, moreover, mirrors the experience of looking at the painting itself. We know how it feels inside the woman because it feels the same way inside us as we gaze upon the painting. And it would be as myopically puritanical to regard this mirroring as nothing more than an extension of the viewer's narcissism as it would to see in the depicted scene only an instance of human vanity. On the contrary, what we are given is "a stable, freestanding view of the outside world,"[16] an image of an autonomous feminine counterpart, seen at a distance, as a whole body; and on our ability to incorporate this spectacle, and feel ourselves mirrored and inwardly enlarged by it, depend not only our own stable self-image, but the possibility of well-being, and the capacity for love. Vermeer's theme in *Woman Putting on Pearls* is not the temptation of the world but (as in the entire sequence of freestanding women) the basis of our trust in it, and in its goodness. Happiness here is simply a matter of being visible, of being in the visible, wedded to it. A more profound commitment to the immanence of value, and to the possibility of fulfillment in this life, it would be impossible to imagine.

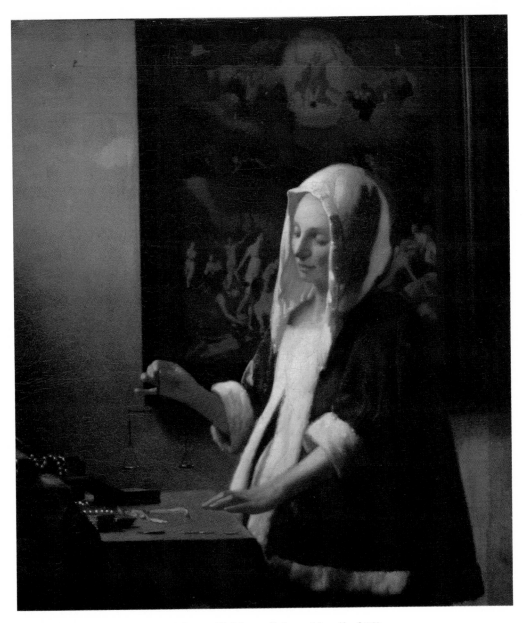

51. *Woman Holding a Balance* (detail of 13)

131

Woman Holding a Balance [51] gives the impression, even more power-fully than *Woman Putting on Pearls*, of being a distillation, and an open assertion, of the values implicit in Vermeer's work as a whole. Indeed, the similarities between the two paintings—the juxtaposition of the mirror and the curtained window, the cloth piled in the left foreground on the heavy wooden table, even the pearl necklace itself, which lies on the table of *Woman Holding a Balance*, a virtual allusion to *Woman Putting on Pearls*—suggest that Vermeer is more conscious than usual in these two paintings of expressing different facets of a single vision.

The values embodied in *Woman Holding a Balance* are asserted over against conventional moral and religious judgment even more explicitly than they are in *Woman Putting on Pearls*. A large baroque painting of the Last Judgment hangs conspicuously on the rear wall of the room, situat-ing the woman within an apocalyptic frame of reference and counter-pointing her gesture. The light that illuminates her breaks into the painting from above, surrounding her with what at first glance may seem ominous, encroaching shadows; its point of entrance, moreover, resem-bles the "lurid yellow nimbus"[17] of the Christ of the Last Judgment.

Commentators who have responded to this thematic counterpoint have almost invariably assumed that the painting in the background provides "the key that unlocks the allegory"[18] of the painting. Thus we are told that the gold coins on the table and the pearls spilling from the jewelbox represent "the dangers of worldliness,"[19] "everything that mortal man tries vainly, in the face of his mortality, to hold on to";[20] and that the woman's presence is an embodiment of Vanitas,[21] or a reminder of "the transitoriness of human life,"[22] or "another statement about the impor-tance of temperance and moderation in the conduct of one's life."[23]

But this, again, is to opt for a meaning that is at direct odds with the immediate spiritual impact of the painting. *Woman Holding a Balance* provides us not with a warning but with comfort and reassurance; it makes us feel not the vanity of life but its preciousness. Against the violent baroque agitation of the painting behind her, the woman asserts a quiet, imperturbable calm, the quintessence of Vermeer's vision. Against its

52. *Woman Holding a Balance* (detail)

lurid drama of apocalyptic judgment, and the dialectic of omnipotence and despair it generates, she poses a feminine judiciousness, a sense of well-being predicated on balance, equanimity, and a pleasure in the finest distinctions. Against a demonic, emaciated fiction of transcendence, she exists as a moving embodiment of life itself, and what is given to us in it. And in all these oppositions, one cannot but feel the effortlessness of her triumph.[24]

The title conventionally given to the painting, *Woman Weighing Gold* or *Woman Weighing Pearls*, is crucially misleading; for close attention [52] makes it clear that the balance itself is empty, save for two gleams of light that highlight either pan (and how entirely appropriate that a gesture so

paradigmatic of Vermeer's art should appear to be concerned with the weighing and balancing of light itself). The woman is testing the truth of the balance before she uses it to make a measurement. And this requires an absolutely steady hand, coordinated with a gaze that originates in inner stillness—much as painting also does. If the gesture is emblematic, what it signifies (and celebrates) is an innate sense of value, the capacity we possess by virtue of a purely inner equilibrium to assess, and pass judgment upon the very means—theologies and moralities as well as physical contrivances—given us to fix our values.

The virtue depicted in *Woman Holding a Balance* is thus, again, ontological rather than moral—indeed, part of the radicalness of the painting is to offer a feminine redefinition of *virtú*. Her scales, and by extension the gesture from which they are suspended, invert the upraised arms of both the supplicant in the lower left of the Last Judgment who desperately abandons himself to a transcendent judgment, and those of the Christ who omnipotently controls the drama that unfolds beneath Him. She bears her grace within herself—her pregnancy, and her capacity to judge, to discriminate, are but complementary aspects of it. Set against the longing to rise, and the clash between gravity and grace, her bell-shaped form takes root in mortality, buoyed up rather than weighed down by it. At the same time, she satisfies no fantasies of omnipotence; though she is the living center of the mysterious equilibrium that holds her world in place, she is content, even fulfilled, in serving anonymously, impersonally, as its fulcrum.

The gesture of her left hand complements the symbiosis of gravity and light, stability and suspension, focused at the fingertips of her right. It recalls earlier details in Vermeer: the hand that preserves the link between the external world and the inwardly absorbed figure of *Girl Asleep at a Table*, and those with which the young woman in *Young Woman at a Window with a Pitcher* [53], a barely embodied, almost weightless presence holding in place a world created by light, "steadies herself in the moment of rebirth."[25] The hand of *Woman Holding a Balance* is the mature, supremely confident realization of those first tentative gestures.

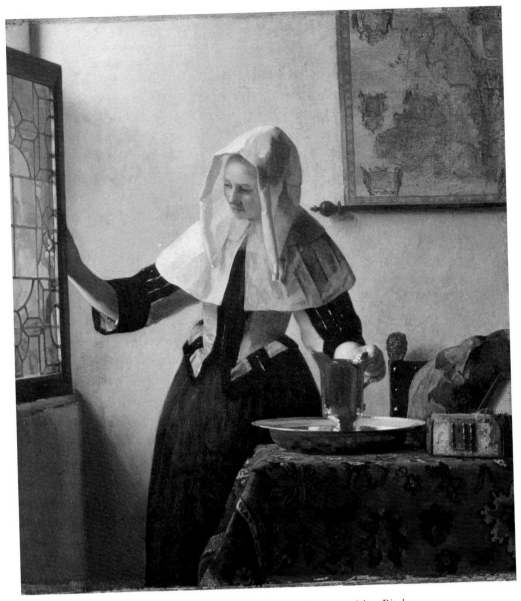

53. Vermeer: *Young Woman at a Window with a Pitcher.*
18 × 16⅛ in.
The Metropolitan Museum of Art, New York

The table on which it rests functions not so much as a physical support (the values affirmed by the painting would largely be lost if we felt her to be leaning against it)[26] as a metaphysical touchstone, an anchor for the mind.[27] The human weaving that covers it elsewhere in Vermeer is pushed back to reveal the thing itself, in its massive, indubitable solidity. The hand that rests lightly, patiently upon it receives infinitely more satisfying, less self-defeating assurance of the world, and the self's presence to it, than the foot with which Dr. Johnson kicked his stone to refute Bishop Berkeley's argument that the world exists only in the mind. Approached humbly, delicately, out of the self's own assurance, external reality reciprocates, bestowing value as well as support (instead of merely re-isolating the self with the pain of a sore toe). The table appears almost to reach out to offer its support; at the same time it seems but the objective extension of the woman's inner certainty.

And if material reality provides assurance for the woman of *Woman Holding a Balance*, it receives a life, a spiritual value from her in turn: as she lays her hand on the table, her gesture is that of a benediction. One again has the sense of the culmination of an idea that has taken many shapes in Vermeer, from the exchange of qualities between the heavy earthenware pitcher and the touch of the woman who holds it in *Woman Pouring Milk* to the impersonal forms that become the coordinates of a world as they gather round the human figure of *Woman in Blue Reading a Letter*. There could scarcely be a greater contrast between this gesture and that of the Christ in the background of *Woman Holding a Balance*, whose upraised arms preside over the wrathful, apocalyptic destruction of everything that is blessed by, and abides in, Vermeer's art.

NOTES

PROLOGUE: *HEAD OF A YOUNG GIRL*

1. Lawrence Gowing, *Vermeer*, 2nd ed. (1952; rpt. New York: Harper and Row, 1970), p. 43. I am indebted to Gowing's work on Vermeer at levels too fundamental to document adequately in footnotes. His insights into Vermeer are the very basis of this study, and are implicit throughout it.

2. Adrian Stokes, *Michelangelo: A Study in the Nature of Art* (London: Tavistock, 1955), p. 84.

3. Compare the riveting effect of Keats's magnificent untitled poem:

> This living hand, now warm and capable
> Of earnest grasping, would, if it were cold
> And in the icy silence of the tomb,
> So haunt thy days and chill thy dreaming nights
> That thou wouldst wish thine own heart dry of blood
> So in my veins red life might stream again,
> And thou be conscience-calmed—see, here it is—
> I hold it towards you.

The dynamic of this poem is similar to that of *Head of a Young Girl* in so many respects—not least of all in the difficult "now" it thrusts upon its audience—that one feels a common problematic of art and its relationship to flesh-and-blood experience must be involved. For an intriguingly relevant discussion of the poem and the "impossible imperatives" of apostrophe in general, see Jonathan Culler, "Apostrophe," *Diacritics* 7 (Winter 1977), pp. 68–69 and *passim*. To bring Culler's discussion fully to bear on *Head of a Young Girl*, we might remark that it is not only the author who addresses the reader in Keats's poem, but the poem itself, or the life in the poem, or from which it is taken, that addresses the poet.

4. *Woman in Blue Reading a Letter* is the only of Vermeer's interiors framed entirely against the rear wall of the room. This enhances the sensation of a moment suspended in vision; yet it also underscores the capacity of the painting to accomplish itself as a world—to establish gravity, depth, and with them a stable sense of space and time—without reference to the room's physical coordinates. (The wall resembles the open sky of *A View of Delft* more than the walls of Vermeer's other interiors.) We take our bearings here ontologically. Her own presence provides balance and stability, becomes a still point about which the image of a coherent, free-standing world can gravitate. The forms of that world reciprocate by protectively enclosing her in "an orderly coolness that nothing will disturb" (Gowing, *Vermeer*, p. 35).

5. It has been suggested that the women in *Woman in Blue Reading a Letter* and *Woman Holding a Balance* are not pregnant at all but merely depicted in accordance with a conventional seventeenth-century ideal of feminine beauty. Yet in none of the similarly clothed women of Vermeer's contemporaries (compare, for instance, Pieter de Hooch's *Woman Weighing Gold* [70]—quite likely painted in imitation of *Woman Holding a Balance*), nor in any of the bell-shaped women of the Van Eycks and their followers, is the *idea* of woman's pregnancy communicated, as it is so powerfully in these two paintings by Vermeer. Their atmosphere is so—pregnant—with a sense of gestation, a sense of life cherished, tenderly cradled, and as such assured of its continuance into the future, that to deny the actual pregnancy where these feelings find embodiment is to resist the values the paintings generate. What does need to be resisted is the purely anecdotal reading of this pregnancy, and the vulgar art-historical fantasies it tends to inspire. One commentator, for instance, suggests pruriently that *Woman in Blue Reading a Letter* is "a variant on a familiar theme, practically the only context in which pregnancy is shown, the 'sickness without a cure' that ails the many languishing girls in Jan Steen's comic scenes of doctors' visits" (John J. Walsh, Jr., "Vermeer," *The Metropolitan Museum of Art Bulletin* 31 [1973], sec. 5). Better, certainly, no pregnancy at all than an interpretation of it that so belittles the painting.

6. *The Love Letter*, as the title it has come to be known by suggests, deliberately arouses in the viewer the sort of prying interest in narrative content that the other Vermeers suppress; it simultaneously depicts and attempts to characterize the nature of the place of viewing to which this sort of interest corresponds. The failure of the painting to achieve anything like the experience of singular, ontologically significant human presence that we expect from a Vermeer is dialecti-

cally linked to the concealed, lifeless gaze for which the scene exists. The expression with which the standing maid regards her mistress—although it probably only indicates complicity and easy familiarity, one inevitably tends to read it as condescension and even something like ridicule or contempt—similarly "objectifies" our own anecdotal viewpoint, which in its apparent interest in the particulars of human life sees everything in terms of "variants on a familiar theme."

It may seem implausible that a painter would paint a picture with wholly ironical or critical intent. But one of the things I hope to establish in the course of this study is the consistently dialectical, conceptual thrust of Vermeer's oeuvre —and the existence within it of a strong potential for critical, even sardonic reflection. His vision largely evolves in terms of a preoccupation with what it is not, what it opposes, and what, at each stage of its progress, it develops out of—hence, to a large degree, the intricate inner coherence of his work. I will argue later that the lifelessness of *Allegory of the New Testament* [46] is also deliberate, and stands in a similarly ironic relationship to *Artist in His Studio* [41], whose uncanny "life" it illuminates by way of contrast.

7. Gowing, *Vermeer*, p. 45.

8. I am indebted for some of the terms of this discussion to the work of Geoffrey Hartman, especially "Maurice Blanchot, Philosopher-Novelist," in *Beyond Formalism* (New Haven: Yale University Press, 1970), pp. 100–103, and "Spectral Symbolism and Authorial Self in Keats's 'Hyperion,'" in *The Fate of Reading* (Chicago: University of Chicago Press, 1975), pp. 57–59, 65–66.

9. *Thus Spake Zarathustra*, Part Two, "Of Immaculate Perception," trans. R. J. Hollingdale (London: Penguin Books, 1961), pp. 145–46.

10. Gowing, *Vermeer*, p. 38.

11. The object on the floor of *Woman Pouring Milk* [54] is almost certainly a footwarmer, of the kind that appears regularly in the work of Steen and Vermeer's other contemporaries. But Vermeer seems interested in it primarily for its phenomenological many-sidedness—it partakes in both sides of virtually all the dialectical oppositions that structure the painting.

There is reason to think, furthermore, that its strangeness is not entirely a matter of our unfamiliarity with the everyday accoutrements of Vermeer's world. It has the look of an object that has strayed outside the boundaries of the human world within which it is known by its conceptual name and function. As such, it tends to enter into opposition with the pitcher that is so securely in hand,

54. *Woman Pouring Milk* (detail of 5)

involved in the fundamental business of life and intimately open to the imagination's humanizing (and eroticizing) impulses. There was a time when this object was thought to be a mousetrap (Piero Bianconi still designates it as such in his usually reliable notes to *The Complete Paintings of Vermeer* [New York: Abrams, 1967], p. 90): perhaps the sense of strangeness that attaches to it subliminally reinforces this perception. As Irving Massey notes: "objects . . . which have not been brought into the life of the mind . . . are the ones that create anxiety. We cannot forget them; they remain unabsorbed; in their neutrality there is something unassimilable and menacing" (*The Gaping Pig: Literature and Metamor-*

phosis [Berkeley and Los Angeles: University of California Press, 1976], p. 63). The sense of fulfillment that emanates from this painting's vision of a perfectly familiar, domesticated human world is predicated on both an impersonal density at the heart of that world (and the woman who epitomizes its openness), and a state of ontological dereliction just outside its boundaries (the figures painted on the tiles at the base of the wall all appear to be itinerants of one sort or another—beggars, wanderers, pilgrims, prodigals). Hence, again, we find a dialectical tough-mindedness in Vermeer where the casual glance might see something bordering on the sentimental. From this point of view, the object on the floor can be seen as a necessary counterweight to the entire accumulation of world that flows away from it.

12. Gaston Bachelard, *The Poetics of Space*, trans. Maria Jolas (New York: Orion, 1964), p. 222.

13. Gowing, *Vermeer*, p. 26.

14. Gowing, *Vermeer*, p. 137.

15. The thick, even, enamel-like black pigment that serves as the background of *Head of a Young Girl* gives emphasis to the face as an image on a surface, the figure of a two-dimensional figure-ground relationship (she stands out against it, but it refuses the illusion of depth). This black paint has been applied in what seems a spirit of negation, as if to deny the porous, receptive qualities of the canvas, its existence as the site of imaginative transformation (or representational illusion, depending on one's mood or viewpoint).

The treatment of the background in *Girl with a Veil* [55], the conceptual pendant of *Head of a Young Girl*, offers an instructive contrast. Here, where the desire, apprehension, and unrest of *Head of a Young Girl* are converted to care, trust, and mutual reassurance, without abdicating from the hermetic, potentially incestuous relationship with the created image—for she, too, is a "daughter," and her life just as radically lacks any context other than our vision—the canvas visibly soaks up the black paint that surrounds the young girl, just as she soaks up the conscience-calmed light that now tenderly, protectively enfolds her. Studied in isolation this painting may tend to evoke a lukewarm response from the viewer, but considered in relation to *Head of a Young Girl* it becomes extraordinarily beautiful and moving. It bestows the grace that *Head of a Young Girl* passionately resists.

16. The left-to-right movement of the light eliminates modeling and tonal contrast exactly where the angle of view would lead us to expect them. The part of the face farthest away from us is the most uniformly luminous area of the painting, and it is defined by a sharp outline against the enamel-like black background instead of by transitional shadows. Note especially how the nose merges indistinguishably with the right cheek: it is one of the most radical yet typically unobtrusive painterly gestures in Vermeer.

17. The light that illuminates the face of *Head of a Young Girl* is associated with the viewer, but it does not exactly coincide with him: it appears to come from a source to our left and slightly above us. It is important to the thought of the painting that we feel the place of the viewer to be a benighted one, and the attraction of the image to involve a desire for warmth and illumination—though, alas, she can only be our moon, not our sun, and though she ultimately draws us into a void, not into the light of day.

Our position vis-à-vis this portrait head is interestingly parallel to that of the soldier vis-à-vis the smiling girl illuminated by the light from the open window on his left in the much more hopeful *Soldier and Young Girl Smiling* [32], and to that of the artist vis-à-vis his similarly positioned model in *Artist in His Studio* [41]. The discussions of these two relationships later in this study bear directly on the issues at stake in *Head of a Young Girl*.

18. *The Lacemaker* [56] presents an antithetical, equally radical statement of face and head and their relationship. The features here appear to be carved or molded out of the head rather than stamped upon it—as if they were its topography, its terrain. The vision is of a benignly corporeal oneness of aspect, and a conviction of reality, an ontological satisfaction (hers and ours at the same time) that inhere in it. Gowing's beautifully accurate response to this painting articulates exactly the experience that *Head of a Young Girl* deprives us of: "weight and volume, the lovely bulk of the head, seem in their lucent translation almost within our measure. . . . We have come upon female life in its whole secluded richness: engrossed in itself it is seen entire and unimpaired" (Gowing, *Vermeer*, pp. 46–47).

19. It is almost as if the two components of the turban existed merely to give form to the spiritual tendencies of the colors they bear. Cf. Wassily Kandinsky: "If two circles are painted respectively yellow and blue, brief concentration will reveal in the yellow a spreading movement out from the center, and a noticeable approach

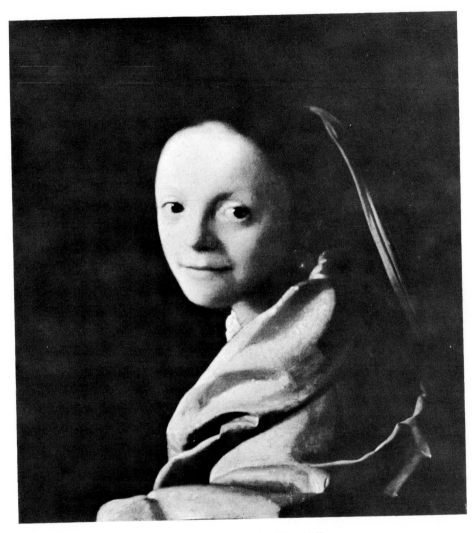

55. Vermeer: *Girl with a Veil.*
17¾ × 15¾ in. Private Collection, New York

56. Vermeer: *The Lacemaker*.
9⅞ × 8¼ in.
Musée du Louvre, Paris

to the spectator. The blue, on the other hand, moves in upon itself, like a snail retreating into its shell, and draws away from the spectator" (*Concerning the Spiritual in Art*, trans. M. T. H. Sadler [New York: Dover, 1977], pp. 36–37). For further speculations on the metaphysics of Vermeer's juxtaposition of blue and yellow, see pp. 167–69, note 21, of the present study.

20. Yet Vermeer's dialectic characteristically eludes this simple antithesis: for the white of the eyes reaches out to us with a value that exceeds in turn that of the pendant's yellow.

21. Only in the triangular area of the canvas bordered by the shoulder, the left cheek, and the straight line of the turban has Vermeer lightened the impasto of the black background and employed tonal contrasts that suggest the depths and shadows of three-dimensional space. It is largely in terms of these "positive" shadows that the roundness, separateness, and withdrawn, recessive qualities of the head are established. The barely indicated back of the neck acquires a special poignancy as one realizes what is at stake in this enhanced area of the canvas.

22. Compare especially the pearl earring of *Girl with a Veil*, where a dialectical opposition with *Head of a Young Girl* is almost certainly intended.

23. Cf. Paul Claudel, *The Eye Listens*, trans. Elsie Pell (New York: Philosophical Library, 1950), pp. 274, 290:

> The pearl at the bottom of the sea is born all alone, of living flesh; pure and round, it frees itself, immortal, from that ephemeral being that has given it birth. It is the image of that lesion which the desire for perfection causes in us, and that slowly results in this priceless globule. Here in the fold of our substance is the pearl which is the metaphysical seed preserved. . . . The soul, wounded and impregnated, possesses deep within itself, a device which permits it to solidify time into eternity. . . .

24. Compare the strangely inert, (sardonically?) contrived resolution of this motif in *Allegory of the New Testament*, where a transparent glass sphere hangs from a blue ribbon tied to the ceiling of the room [57].

25. The line of this displacement is almost exactly indicated by the diagonal of the blue part of the turban. It is also reinforced by the positioning of the gleam in the upper left of the pearl, so that it echoes the place of the white of the eye with respect to the iris and pupil (as well as the place of the gleam on the edge of the iris itself) and at the same time points in its direction.

57. *Allegory of the New Testament* (detail of 46)

26. Cf. John Donne, "A Valediction: Of Weeping":

> Let me pour forth
> My tears before thy face, whilst I stay here,
> For thy face coins them, and thy stamp they bear,
> And by this mintage they are something worth,
> For thus they be
> Pregnant of thee;
> Fruits of much grief they are, emblems of more;
> When a tear falls, that Thou falls which it bore,
> So thou and I are nothing then, when on a divers shore.

ART AND SEXUALITY

ı PAINTERLY INHIBITIONS

1. Huysmans' description of Degas' women exhibits the very compulsion to degrade that he claims to find in the paintings themselves:

> . . . the better to recapitulate her origins, he selects a woman who is fat, pot-bellied, and short, burying all grace of outline under tubular rolls of skin, losing, from the plastic viewpoint, all dignity, all grace of line; making her, in fact, regardless of the class to which she may belong, a pork-butcher's wife, a female butcher, in short a creature whose vulgar shape and heavy features suggest her continence and determine her horribleness!
>
> Here we have a red-head, dumpy and stuffed, back bent, so that the sacrum sticks out from the stretched, bulging buttocks; she is straining to curl her arm over her shoulder so as to squeeze a sponge, the water from which is trickling down her spine and splashing off the small of her back; here we have a blonde, thick-set, stocky, standing up, also with her back turned; she has completed her maintenance work and, with her hands on her rump, is stretching herself with a rather masculine movement, like a man warming himself in front of the fire, lifting his coat-tails. Then again we see a big, squatting lump leaning right over to one side, raising herself on one leg and passing an arm underneath, to catch herself in the zinc basin. The last of them, seen full-face for once, is drying the upper part of her belly.
>
> Such, in brief, are the merciless positions assigned by this iconoclast to the being usually showered with fulsome gallantries. In these pastels there is a suggestion of mutilated stumps, of the rolling motion of a legless cripple—a whole series of attitudes inherent in woman, even when she is young and pretty, adorable when lying down or standing up; but frog-like and simian when, like these women, she has to stoop to masking her deterioration by this grooming (*Certains* [Stock, 1889]; quoted in Jean Bouret, *Degas*, trans. Daphne Woodward [New York: Tudor, 1965], pp. 190–91).

Isolated in his masculinity by these women who exist apart from him, without regard for his presence, the latent misogyny of the critic emerges—which

he then displaces onto the artist. One is reminded—but by Huysmans, not by Degas—of Swift's Strephon. It is the great achievement of Degas to find grace and nurture in the vision that generates the self-reflexive male disillusionment of Swift's misogyny.

2. Elie Faure, *History of Art: Modern Art*, trans. Walter Pach (1924; rpt. New York: Garden City, 1937), pp. 394–96.

3. François Mathey, *The Impressionists*, trans. Jean Steinberg (New York: Praeger, 1961), pp. 188–89.

4. For a reconsideration of Degas that supports this view of his paintings, see Norma Broude, "Degas's 'Misogyny,'" *Art Bulletin* 59 (1977), pp. 95–107.

5. In a few of his monotypes Degas does include men in spaces that belong to women. In almost every instance they are portrayed as uncomfortable and isolated in their attendance, excluded by the black, funereal trappings that insure their social and sexual status from the uninhibitedness the women manifest in their presence. Openly self-contemptuous images of male desire often appear in these monotypes; yet even in the most disturbing ones [58], it is remarkable how free the portrayal of the women themselves is from masculine inhibition and its retaliatory, misogynistic animus (in this they differ profoundly from Manet's *Olympia*, Cézanne's *A Modern Olympia* and *The Eternal Female*, or even Picasso's numerous variations on the theme of isolated male attendance on an oblivious female presence). In *Woman Combing Her Hair* [59], for instance, the woman's open, uninhibited presence is rendered simply, directly, even tenderly, and certainly without any mediating animus; indeed, even the dark feelings about the male self are strangely transcended. Degas seems positively to enjoy the discomfiture of the suitor with whom as a man he is so complexly identified. The sense of humor here seems on reflection disturbingly cruel, but its direct manifestation in the monotype is benign and wryly sympathetic. The mood of the whole is acceptant and self-forgiving; yet the split between the artist and the erotically motivated male seems absolute, and the vision offered would seem to deny the very possibility of intimacy, sexual or otherwise, between men and women.

6. "From Poetic Realism to Pop Art," *Modern Language Notes* 84 (1969), p. 672.

7. Degas comes closest to this aspect of Vermeer's paintings in the small, free-standing nude statuettes found in his studio after his death. Yet even here it is the impression of the artist's attachment to them that largely accounts for what is so moving about their presence. Degas' reply when asked why he neglected to cast these figures in bronze reveals the depth of involvement that his misogynistic

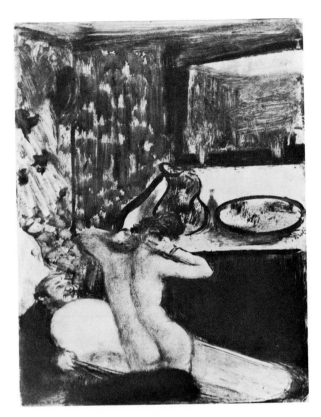

58. Degas: *Admiration.* 8⁷⁄₁₆ × 6⁵⁄₁₆ in. Université de Paris,
Bibliothèque d'Art et d'Archéologie (Fondation Jacques Doucet)

remarks and formalistic manifestoes disguise: "It's too great a responsibility. Bronze is for eternity. You know how I like to work these figures over and over. When one crumbles, I have an excuse for beginning again" (quoted in Leo Steinberg, *Other Criteria* [London: Oxford University Press, 1972], p. 418, citing Victor Frisch and Joseph T. Shipley, *Auguste Rodin: A Biography* [New York: Frederick A. Stokes, 1939], p. 312).

8. Vermeer's arrangement has long been recognized to be based on that of Jacob van Loo's *Diana and Nymphs* [60]. Vermeer's intricate reorganization of Van

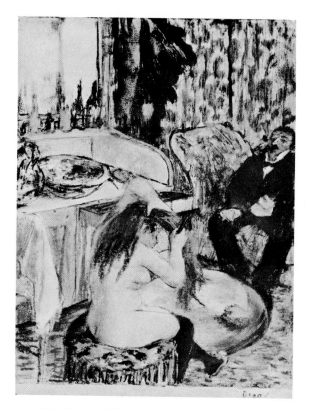

59. Degas: *Woman Combing Her Hair.*
8⁷⁄₁₆ × 6⁹⁄₁₆ in. Location unknown

Loo's scene offers an especially vivid demonstration of the elaborate responsive-
ness to the work of his contemporaries that underlies the private, idiosyncratic
nature of his work. Especially interesting is the metal basin and the crumpled
towel that looks like a bird about to drink from it at the bottom of the Vermeer.
The *trompe l'oeil* aspect of this detail seems highly uncharacteristic of Vermeer
until we notice that it very consciously replaces a plate filled with two real but
dead birds in the Van Loo. Vermeer thus comes to the themes most private to him
via a reflection on his engagement with the work of his contemporaries: the "life"
of the artifice with which he counters the "nature mort" of their gross naturalism;

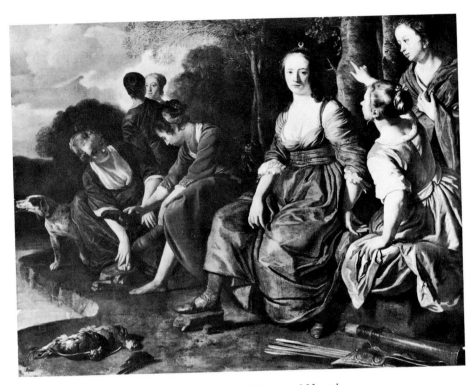

60. Jacob van Loo: *Diana and Nymphs.*
52¾ × 63¾ in. Bode Museum, East Berlin

art's redemptive impulses, its desire to transform death and materiality into a chaste purity; and the invisible residue of mortality that survives into the work of art, the other side of the immaculateness it cherishes.

9. All of Vermeer's early paintings could technically be called "genre scenes," but the term will be used in this study to refer only to *Woman Drinking with a Gentleman, Gentleman and Girl with Music,* and *Couple with a Glass of Wine.*

10. Gowing, *Vermeer,* p. 52.

11. The order in which *Woman Drinking with a Gentleman, Gentleman and Girl with Music,* and *Couple with a Glass of Wine* are discussed here is the one most commonly assigned them in recent editions of Vermeer. (For a convenient summary of the order in which the paintings appear in the important modern editions of

Vermeer, see Christopher Wright, *Vermeer* [London: Oresko, 1976], pp. 82–85.) None of the three paintings is dated; the "development" being analyzed is conceptual, not chronological. *Woman Drinking with a Gentleman* does give the impression, both in idea and execution, of being the earliest of the three; while *Couple with a Glass of Wine*, with its almost schematic elaboration of what the other paintings more intuitively embody, seems most likely to have been the last of the three to be painted. But all three were obviously painted at the same stage of Vermeer's development, and they could be arranged in any chronological order without affecting the basis of the interpretation advanced here. In terms of size, as well as design and color scheme, in fact, *Woman Drinking with a Gentleman* (25½ × 30¼) and *Couple with a Glass of Wine* (30¾ × 26½) are obvious pendants, while the smaller *Gentleman and Girl with Music* (14½ × 16½) links up with the Frick *Soldier and Young Girl Smiling* (19 × 17), which is usually dated earlier than the other paintings. The similarity in size between the latter paintings reinforces the visual link discussed in note 17, below.

12. Pierre Descargues, *Vermeer*, trans. James Emmons (Geneva: Skira, 1966), p. 128.

13. The position of the man vis-à-vis the woman—his left arm encircling her, his right hand, thumb up, almost touching hers, recalls the openly erotic embrace of *The Procuress* [29]. Notice also the illusion of continuity between the sheet of music that the man touches and the white garment that covers the woman's lap—possibly another suggestion of the desire for erotic contact that is being sublimated in the innocent aesthetic activity of music making.

14. Harry Berger, in an interesting discussion of *Gentleman and Girl with Music*, applies Gowing's description of the expression on the face of the model in *Artist in His Studio* [41] to that of the woman who looks at us from the earlier painting: "She both invites the painter's attention and as tenderly wards it off" (Gowing, *Vermeer*, p. 54; Berger, "Conspicuous Exclusion in Vermeer: An Essay in Renaissance Pastoral," *Yale French Studies* 47 [1972], p. 255). Yet what is so unsettling about the look is that it neither invites the artist's attention *nor* wards it off. The expression of *Artist in His Studio* indicates a *resolution* of the tensions that the gaze of *Gentleman and Girl with Music* exacerbates.

15. Both Berger and Gowing refer to the painting as *Girl Interrupted at Her Music*, but then go on to base their interpretations on the assumption that it is the man within the painting who has interrupted her (Berger, "Conspicuous Exclusion,"

pp. 254–55; Gowing, *Vermeer*, pp. 48–49, 113–17). Yet this contradicts every viewer's immediate sensation of being himself the source of interruption of a scene quietly and intimately in progress. It also suggests the latent doubling that tends to occur between the viewer and the male figure within the painting, and the subsequent tendency to take the look that confronts us as a displaced response to his attention.

16. For a discussion of this motif in the work of Vermeer's contemporaries, see E. de Jongh, "Erotica in Vogelperspectief. De dubbelzinnigheid van een reeks 17de eeuwse genrevoorstellingen," *Simiolus* 9 (1968), pp. 22–74.

17. The chair in *Woman Drinking with a Gentleman* represents the world of things; in *Gentleman and Girl with Music* it signifies a human absence. Its position in the extreme foreground of the latter painting recalls the chair of *Soldier and Young Girl Smiling* [32]; perhaps there is a subliminal memory of the problematical male consciousness that occupies it in the (probably) earlier painting. If so, has this consciousness receded to the place of the artist/viewer, to haunt the scene of its absence, or has it been fully accepted into the space of the painting, where it now leans over the object of its attention, in intimate contact with her?

18. Notice the similar disposition of the two female figures in the much later Beit *Letter Writer* [61]. Here, however, where the subject is the twin-aspectedness of woman, and no importunate male intrudes (though a communication is still the basis of the occasion), Vermeer's dialectic becomes generous and fertile.

19. The woman in *Couple with a Glass of Wine* is similarly counterpointed by the beautifully rendered heraldic figure that looks on from the cut-glass window [22]: tall and upright, capable and regal in her bearing, holding in her hand what appears to be a serpent wound several times about itself, she is the residue of a remote chivalric past, a romantic and heroic figure whose opposition to the woman who so mawkishly responds to the ridiculous serpentine advances of her suitor could scarcely be more extreme or sardonic. For interesting speculations about the heraldic meaning of this device and Vermeer's symbolic use of it, see A. P. Mirimonde, "Les sujets musicaux chez Vermeer de Delft," *Gazette des Beaux-Arts* 57 (1961), p. 46.

20. The mawkish expression on the woman's face is probably partly due to, or at least falsely accentuated by, a faulty restoration. Yet it is in harmony with the painting's overall mood and conception. The active distaste for the transaction in which she is involved is the organizing principle of the painting; it can scarcely be

a matter of accident. It is possible, however, that her expression in its original form would have elicited something more subtle from the viewer than mere contempt. Gowing's account of the force with which she meets the viewer's eyes—"as if in appeal to be released from the oppressive charade" (*Vermeer*, p. 117)—is *almost* right, and could easily be assimilated into the reading of the painting being proposed here.

21. *Girl Asleep at a Table* and *Girl Reading a Letter at an Open Window* are usually dated slightly earlier than the three genre scenes. Although the stylistic evidence for this chronology is tenuous, I do not mean to question it in speaking of changes that take place in the transition from the paintings of couples to those of single women. The beginning of Vermeer's oeuvre is marked by dialectical alternation rather than clear-cut development (the first two paintings, *Christ in the House of Martha and Mary* and *Diana and Her Companions*, already embody the two poles of his thought), with the scenes involving interaction between the sexes outnumbering those of female solitude eight to three. Although the difference between *Girl Asleep at a Table* and the three genre scenes is essentially conceptual, it does prefigure the development that evolves over the long course of Vermeer's work: after *The Concert* and *Couple Standing at a Virginal*, men and women will share the same space in only one of the approximately twenty-five subsequent paintings—and then equivocally, in *Artist in His Studio*.

22. The association of this object with male presence is retrospectively confirmed by its reappearance in *The Concert* [34] and *Couple Standing at a Virginal* [37].

23. An unskillful cleaning has left this object virtually unidentifiable. Armand Pruvot (*Connaissance des Arts* 252 [February 1973], p. 27) also perceives it to be an overturned glass, and points out that the luminous reflection on its surface can be construed as the head of a man in a black coat with a white collar. This detail reinforces the thematic concerns of the painting (especially in the light of what radiographs have revealed—see note 27, below), although it remains, especially given the painting's present condition, a highly subjective perception. If, however, the object is an overturned wine glass—tipped forward toward the viewer—then we can speculate that in its original condition it would have resembled the transparent glass sphere that hangs from the ceiling in *Allegory of the New Testament* [46]. In one case a convex surface faces the viewer, in the other, a concave one. The sphere of the later painting tantalizingly reflects the space of the artist—indeed, that seems its crucial function within the economy of the

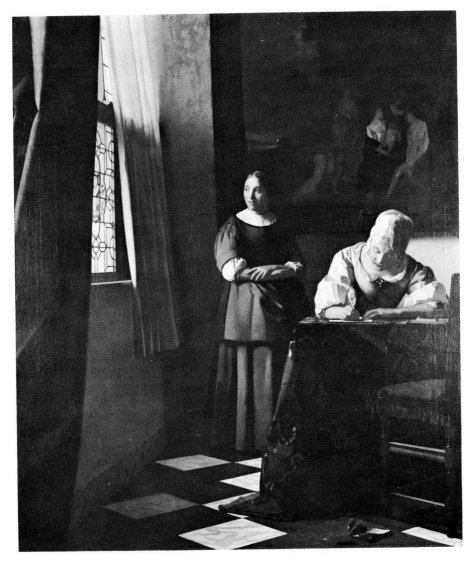

61. Vermeer: *Woman Writing a Letter, with Her Maid.*
28 × 23¼ in. Beit Collection, Blessington, Ireland

painting; the glass of *Girl Asleep at a Table* might well have done so too. The dialectic between the reflections on the surface of this object in the foreground focused on the artist/viewer and the mirror that beckons to him from the depths of the painting would certainly be in keeping with the vision of the whole.

24. Gowing, *Vermeer*, p. 51.

25. There is disagreement over what the attitude of the central figure is meant to signify. In the 1696 sale, the painting was catalogued as "Een dronke slapende meyd aen een tafel." More recent iconographic investigations have identified it variously as the grief of disappointed love and as the sleep of Idleness or Sloth. But the pose seems obviously calculated to resist the moral, psychological, and anecdotal frames of reference it may initially evoke. Vermeer is more interested in portraying, at a purely phenomenological level, a state of self-absorption in which opposites converge: sleep and wakefulness, dream and conscious reverie, abandonment and concentration of self, full and empty consciousness. Perhaps at the heart of the painting is a statement about art itself, or the creative imagination, as an unstable, paradoxical fusion of grief, desire, well-being, and lassitude.

For a further analysis of the deliberate ambiguity of the painting, see the epilogue to this study, "Meaning in Vermeer," pp. 124–26.

26. Madlyn Kahr, "Vermeer's *Girl Asleep*: A Moral Emblem," *Metropolitan Museum of Art Journal* 6 (1972), p. 127.

27. X-ray photographs of *Girl Asleep at a Table* reveal the head and shoulders of a man wearing a hat beneath the mirror, and a dog standing in the half-open doorway, looking intently into the concealed space of the room in the background [62]. The painting is thus a transitional piece in the literal sense: we can observe Vermeer through these uncharacteristic revisions substituting a direct imaginative involvement with his subject matter for a mediated, ambivalent representation of it, and in the process removing certain psychological impediments to his vision—the dog in the original composition directs yet at the same time blocks our passage over the threshold, represents our disembodied curiosity and desire yet at the same time stands alert and suspicious of it.

28. The "grief" of the young girl has more to do with death, with absolute loss, than with the sorrows of disappointed love. The cap that she wears is a "widow's peak": and though it was evidently no longer worn exclusively by widows in Vermeer's day, the signs of male absence that surround it in his painting are

62. *Girl Asleep at a Table*
(X-ray detail)

strong enough to evoke, if not pin down, the experience to which its name refers. One might also note the "tear-like" pearls that hang from her ears: indeed, the painting as a whole is like a preliminary layout of the themes and emotional vectors that converge in *Head of a Young Girl*.

29. The androgynous nature of this pitcher suggests the complexity of the psychic adjustments and exchanges that underlie (within the sphere of male consciousness, at least) the achievement of mature sexuality. The painter bestows upon woman the phallic object, entrusts it to her possession; and in her hands it opens to him in return as the lack, the inner mystery that constitutes (for him) her sexual nature. In giving her what he has, he discovers in her what he lacks—not just maternal nourishment but a good image of his own phallic sexuality. The trickle of milk into the open, receptive bowl transforms the more obviously sexual connotations of the coin about to drop from the cavalier's fingers into the woman's palm in *The Procuress*; it is like an act of insemination that initiates the generative flow of bread outward toward the viewer.

II TWO EARLY PAINTINGS

1. For a fuller discussion of Vermeer's subversive handling of the genre conventions of his time, see the epilogue to this study, "Meaning in Vermeer."

2. As is the case in Rembrandt's *The Jewish Bride* [63], a painting that is in many ways the dialectical opposite of *The Procuress*. The consciously willed (and oddly melancholy) gesture with which the husband touches the breast of his wife offers an especially rich contrast with the similar gesture of the man who leans over the woman in *The Procuress*. Although Rembrandt laboriously wills that his gesture should convey an ethically meaningful tenderness, he still envisions it and blocks it in terms of the inherited images of Venal Love [64]; whereas Vermeer, concerned with the visceral experience of sexuality itself, transcends the old, corrupt configurations altogether.

3. Cf. the Elyas *Merry Company* reproduced in Walsh, "Vermeer," pl. 44, and Walsh's comment on it.

4. It may even be misleading to refer to the vessel in her hand as a "wine glass." The liquid in it has the clear, limpid look of water; it is certainly meant to

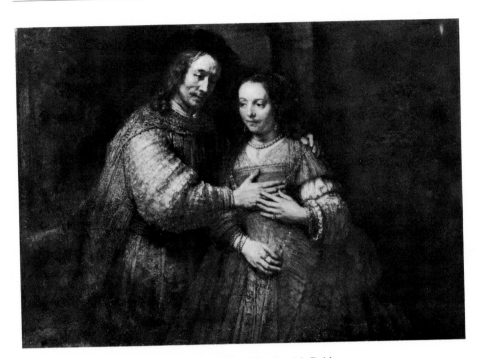

63. Rembrandt: *The Jewish Bride*.
47¾ × 65½ in. Rijksmuseum, Amsterdam

contrast with the murky wine in the hand of the cavalier on the left. It appears a more apt counterpoint for purity than for corruption. For iconographical support of this view, see Irwin Panofsky, *Early Netherlandish Painting*, vol. 1 (Cambridge, Mass.: Harvard University Press, 1953), p. 144.

5. A complicated iconographical tradition depicting an artist in his studio playing a lute or violin instead of working at his canvas was in vogue among Vermeer's Dutch and Flemish contemporaries. The underlying theme, as Hans Joachim Raupp has shown ("Musik in Atlier," *Oud Holland* 92 [1978], pp. 106–28), is the conflict between the artist's vocation and the temptations of hedonistic indulgence. The theme, as we might expect, is typically moralized in the opposite direction from the thrust of *The Procuress*, where sexuality bestows the worldiness—here an ontological positive and not a moral negative—from which the artist is cut off.

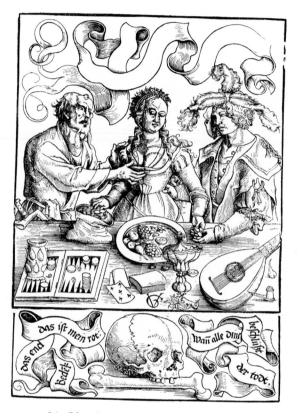

64. Urs Graf: *Venal Love*. Woodcut.

6. The good breast, that is, full and intact, triumphantly realized within a mature sexual relationship—and thus also an image, a sensual experience, of *phallic* confidence and repose. Note the contrast with the artist-figure's sterile, half-hidden grasp of the lute handle.

7. In the dialectic of active and passive, open and closed, secured and suspended gestures in terms of which the flow of hands across the painting is organized, the hands of the isolated cavalier are counterpointed primarily with those of the woman on the right, and not those of his male counterpart.

8. Our position here is thus similar to that of the dark, voyeuristic figure that hovers over the shoulder of the sexually engaged cavalier in *The Procuress*.

65. *Girl Reading a Letter
at an Open Window* (detail of 15)

There are many subtle variations in Vermeer on this motif of a detached, reflective presence or half-presence hovering over the shoulder of a figure absorbed in the immediacy of the moment. The thematic use of the lion's-head finials in the early paintings, and the twin-aspectedness of the figures in *Couple with a Glass of Wine* and the Beit *Letter Writer* have already been discussed; the mirror-image in *Couple Standing at a Virginal* [37] and the place of the viewer in *Artist in His Studio* [41] will be treated in the next chapter. A particularly beautiful instance is the partial reflection in the window of the Dresden *Letter Reader* [65]. This image is on much better terms with the girl who reads the letter than we are

with the soldier of *Soldier and Young Girl Smiling*, even though the two relationships are positionally almost identical. It will not be until *Artist in His Studio*, in the relationship between the viewer and the depicted artist, that Vermeer will portray in masculine terms the reflective well-being that he associates from the first with feminine experience.

9. P. T. A. Swillens notes that a "strong perspective divergence" is generally characteristic of Vermeer's paintings, and in some instances is even more pronounced technically (though not affectually) than in *Soldier and Young Girl Smiling* (*Johannes Vermeer, Painter of Delft, 1632–1675*, trans. C. M. Breuning-Williamson [Utrecht: Spectrum Publishers; New York: Studio Publications, 1950], p. 98). But Berger ("Conspicuous Exclusion," p. 258) is surely right in claiming that the effect is not, as Swillens suggests, to give the spectator the illusion that he is in the room, but rather "to assimilate the officer more closely to our space and remove the girl in her radiant cubicle farther from us."

10. Gowing discusses the conventions upon which the painting is based, and reproduces an especially interesting series of paintings by Vermeer's contemporaries, in *Vermeer*, pp. 104–109. The gestures of the cavaliers in the two *Backgammon Players* by De Hooch [66] and Dirk Hals (reproduced in Gowing, p. 105) are almost identical to the bent hand of Vermeer's soldier; the comparison offers a particularly striking example of how the common property of seventeenth-century Dutch painting is assimilated by Vermeer's idiosyncratic vision.

11. The soldier's hand takes on a special poignancy in the light of his visual resemblance to the cavalier whose hands are so richly engaged in *The Procuress*.

12. Vermeer's handling of paint enhances the contrast between the respective presences of the central figures of *Soldier and Young Girl Smiling*: flat, smooth pigment for the projected soldier; "grainy, finely scumbled, light-catching paint" for the materiality of the woman and the objects closely associated with her (Walsh, "Vermeer," sec. 2).

13. Vermeer provides structural cues for the dialectic between the two tendencies of the relationship: the soldier's perspective is aligned with the sharply receding diagonals of the window, while the woman's is associated with the strong horizontal of the map above her head.

14. Berger, "Conspicuous Exclusion," p. 260.

15. Maurice Merleau-Ponty, *The Visible and the Invisible*, trans. Alphonso Lingis, ed. Claude Lefort (Evanston: Northwestern University Press, 1968), p. 134.

66. Pieter de Hooch: *Backgammon Players.*
The National Gallery of Ireland, Dublin

16. The map on the wall of *Soldier and Young Girl Smiling* provides a subtle counterpoint to the tendency of the boundaries and lines of force between the couple to reverse themselves. Vermeer has inverted the cartographic conventions of his time as well as the psyche's natural symbolism by assigning the color blue to areas designating land masses and brown to those designating water. (In doing so, he almost certainly altered the appearance of his immediate source: see James A. Welu, "Vermeer: His Cartographic Sources," *The Art Bulletin* 57 [1975], p. 532.) As a result, the space between things takes on a shape, a substantiality, a focal importance; and we find ourselves looking at conventional boundaries with

a sense of unfamiliarity, a sense of curiosity usually reserved for unexplored territory.

17. Berger ("Conspicuous Exclusion," p. 259) notes this detail and interprets it in a similar light.

18. The hole-in-the-canvas effect has already been mentioned in connection with the hat of the cavalier in *Woman Drinking with a Gentleman*; it is even more prominent in the hat of the artist in *Artist in His Studio*. All these hats, which characterize Vermeer's thinking about male presence throughout his work, stand in opposition to the aura that emanates from Christ's head in what is very likely his first painting, *Christ in the House of Martha and Mary* [47]. It is as if Vermeer spent the rest of his career chastizing the presumptuousness of the self-aggrandizing male fantasy that in this early work he openly and rather uncritically indulges.

19. Ludwig Goldscheider, *Jan Vermeer: The Paintings* (London: Phaidon, 1958), p. 19.

20. Berger, "Conspicuous Exclusion," p. 259.

21. Gowing, *Vermeer*, p. 51.

22. Berger, "Conspicuous Exclusion," p. 258.

III THE ENIGMA OF THE IMAGE

1. The slice of sky in the landscape above the seated woman inverts the shape of the harpsichord lid; a clump of dark foliage occupies a place in the former that roughly corresponds to the area of the latter upon which the man's head is superimposed.

2. Gowing, *Vermeer*, p. 44. This profoundly feminine presence watches over the site of the painting like a kind of presiding genius of the place: it takes the place of the standing woman of *The Concert*, as Vermeer's vision moves from the nearly anecdotal into the archetypal. Hence, too, perhaps, its "sphinx-likeness": the tendency to see stretched-out paws is encouraged by the memory of the lion's-head finials that protect the space of so many of the earlier paintings.

3. A similar use of long and short crossing diagonals is employed in *Woman Pouring Milk* and *A Girl Asleep*. The relevance of the latter to *Couple at a Virginal* is

particularly evident: the short diagonal leads past an area of material, sensual density to the sleeping girl; the long one through empty space into a sparsely furnished, meditative space in the far background of the painting. The structural device in both instances grounds a dialectic of the imagination. Geoffrey Hartman's discussion of an imagination in the novels of Virginia Woolf "which can either actively fill space or passively blend with it and die" is obviously relevant, both here and in what follows: see "Virginia's Web," in *Beyond Formalism*, pp. 71–84, *passim*; the passage quoted is on p. 73.

4. Gowing, *Vermeer*, p. 18.

5. Descargues, *Vermeer*, p. 81.

6. Gowing, *Vermeer*, p. 46.

7. The dialectic of illusionistic space and painted surface that is so integral an aspect of Vermeer's work is thus self-consciously embodied in the stylistic extremes of the two *Delft* paintings. In *A Street in Delft*, moreover, we have anecdotal as well as intuitive evidence that suggests the "Proustian" connotations of the paintings may well be the rationale rather than the accidental effect of their stylistic preoccupations. According to Swillens's reconstruction (*Johannes Vermeer*, p. 93f.), the painting is an exact transcription of the view from the rear of the window of Vermeer's house onto the street where he had lived since childhood. The buildings depicted are the Old Men's and Women's Almshouses, known by Vermeer's contemporaries as ancient, pre-reformation institutions. The building and the archway on the right were demolished in 1661 or shortly after to make room for the new St. Luke's Guild Hall—implying that Vermeer, from what we can conjecture about the chronology of his work, painted the scene in the shadow of its impending destruction, or perhaps even from a memory of something that no longer existed. (Due largely to the fire of 1652 and the explosion of 1654, there had grown up in Delft a genre of city views that reconstructed lost buildings or recorded those threatened with destruction; see Albert Blankert, *Johannes Vermeer van Delft 1632–1675*, with contributions by Rob Ruurs and William van de Watering [Utrecht & Antwerp: Uitgeverij Het Spectrum B.V., 1975], trans. as *Vermeer of Delft: Complete Edition of the Paintings* [London: Phaidon, 1978], p. 36f., where it is suggested that the phenomenon of the city view per se, an innovation of the 1650s, originated in these motives.)

The objective situation of *A Street in Delft* may thus have provided the elements that overdetermine the act of representation in all of Vermeer's greatest

work: the enigmatic personal investment (part urgency, part wistfulness) in what seems no more than a direct visual transcription of what lies before the eyes; the ambiguous temporality of the space in which the image exists; the lingering sense that the material reality and the stable present which the painting is at such pains to record and convince us of are fictions that exist only on the painted canvas. It may even have been in *A Street in Delft* that these themes, prompted by the external situation, "come to consciousness" in Vermeer's work. It is generally agreed that the painting comes in Vermeer's development somewhere around the transition from the genre scenes to *Couple Standing at a Virginal* and the later, fully mature paintings.

8. Wright, *Vermeer*, p. 11.

9. The picture that is partly visible on the wall behind the man confirms that he is meant to be taken as rapt rather than indifferent. Gowing shows that there can be discerned in it "a man, a prisoner, kneeling with his hands bound behind his back," and demonstrates convincingly that it is part of a *Roman Charity*, "calling to mind an inconceivably abject dependence of man upon woman" (*Vermeer*, pp. 54, 124; see p. 123 for a reproduction of an example of the type that establishes the identification beyond any doubt). The presence of this painting within the painting has a somewhat different effect than the ironic or dialectical counterpoint supplied by the paintings within the other scenes of interaction between the sexes. So little of it is revealed that it serves as a kind of overt insistence on the presence of meanings private to the artist (somewhat in the manner of the Cupid that hangs on the wall of *Girl Asleep at a Table*), a partial disclosure of what lies at the heart of the matter, prior to any dialectical engagement.

10. Gowing, *Vermeer*, p. 44.

11. The hands of the man in *Couple at a Virginal* also recall those of the Christ in *Christ in the House of Martha and Mary* [47]; the woman and her reflected aspect, moreover, pivot around him much as Martha and Mary are disposed in relation to Christ.

12. And surely not, as translated in Bianconi, the comparatively insipid "Music is the companion of joy, and medicine that of pain" (*Complete Paintings*, p. 91).

13. Gowing, *Vermeer*, p. 52.

14. Gowing, *Vermeer*, p. 52.

15. Bianconi, *The Complete Paintings*, p. 91.

16. I am indebted to Hal Rowland for this perception.

17. Lawrence Gowing, "*An Artist in His Studio*: Reflections on Representation and the Art of Vermeer," *Art News Annual* 23 (1954), p. 89.

18. The allegorical interpretations of *Artist in His Studio* are summarized by Bianconi, *Complete Paintings*, p. 94, and Welu, "Vermeer's Cartographic Sources," pp. 540–41. The painting's distance from the allegory intended by the artist within it is reinforced whether the model's accessories are those of Fame or Clio, the Muse of History: on the one hand his project is cast in a humorous perspective by his happy anonymity, on the other by the "eternal present" in which he paints, insulated from anything like an intrusion of historical reality (the map on the wall is merely an aesthetic object as far as he is concerned, and it certainly plays no part in the vision he is in the process of committing to his canvas). It would not be unlike Vermeer to have intended a conflation of these two allegorical figures, since they refer us, albeit ironically, to complementary aspects of the painting's larger vision.

19. One might think, by way of contrast, of the poised brush of the artist in Velasquez's *Las Meninas* [67].

20. The crude, featureless rendering of the artist's hand is thus a thematic calculation on Vermeer's part, and not merely a quirk of his idiosyncratically optical style. It is also another indication of his comic approach to the issue of the artist's virtuosity, his ego-effacing attitude in this work toward authorial status. Again, the contrast with *Las Meninas*, and its equally ironical meditation on authorship, comes to mind. The hands of these two artist-figures—indeed, the paintings themselves—might have been conceived together, in intimate dialectical opposition.

21. The blueness of the leaves becomes especially interesting in the light of the directions given in Cesare Ripa's *Iconologia* for the representation of Clio's laurel crown: "The laurel crown expresses that like the laurel which is always green and maintains its greenness for a long time, that also therefore through History the past as well as the present lives eternally" (quoted and translated by Welu, "Vermeer's Cartographic Sources," p. 540). *Artist in His Studio*, however, is concerned with the passage of reality not into History but into Art, where the green of the present is preserved by transforming it on the chords of "the blue guitar." In this painting the tendency of green pigment to deteriorate into blue with the passage of time (due to the fading of the relatively unstable yellow component) is calculated in advance, and given thematic significance—we can actually witness

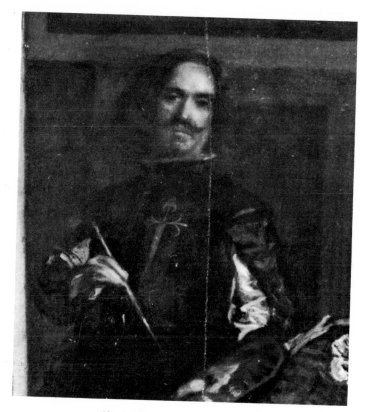

67. Velasquez: *Las Meninas*.
125 × 118½ in. Museo del Prado, Madrid

the process taking place by following the pattern of leaves up the diagonal of the tapestry. Thus, at the point of maximum intensity in the painting, where the yellow of the model's book comes into contact with the blue of her shawl, the pigments which if allowed to mix would produce green lovingly embrace instead—an arrangement designed for *painting's* eternity.

Could the blue foliage of *A Street in Delft* also be a calculation on Vermeer's part rather than a result of accidental deterioration? For this painting too is concerned with a dialectic between the passage of time (cf. the weathering of the bricks and shutters of the street's facade, and its echo in the wear of the painting's

surface) and the eternity of the present (or painted) moment. It too manages to focus the process through which life becomes image, and the ambiguous time —remote and other as well as all present—into which life thereby enters. The rendering of the foliage (the impasto is thicker and more encrusted than with any of the other materials or textures that might seem to call for similar treatment) and the difficulty of locating or making sense of it in real space make it look more like a growth of paint (or an area of deterioration) on the surface of the canvas than a growth of vegetation on the wall of the facing building. (The denial of recession or spatial interval also reinforces this sensation.) I grant that this line of speculation is far-fetched, yet I find the theory that the paint has degenerated into this condition from an original green hardly less so. The blue of the foliage is much more pure and luminous—it almost matches that of the sky that shows through the clouds—than that of the faded trees in *A View of Delft*, and its juxtaposition with the perfectly preserved green of the shutters is at least provocative. (Note, in this context, the juxtaposition of the blue and yellow dresses in *Diana and Her Companions*, counterpointed by yellow-green to olive-green foliage in the background and a small, bright green plant in the lower foreground; also the juxtaposition of blue, yellow, and green areas in *Woman Pouring Milk* and *A View of Delft*, and the subtle, perfectly preserved interplay among the three colors in *Soldier and Young Girl Smiling*. A look at Vermeer's oeuvre as a whole suggests not only that his green is stable but that the derivative nature of its existence in the realm of painting was of great interest to him.) The scientific analysis of Vermeer's pigments by Hermann Kühn, "A Study of the Pigments and Grounds Used by Jan Vermeer," in *National Gallery of Art Report and Studies in the History of Art* II (Washington, 1968), pp. 154–202, provides much information but sheds no light on this particular issue.

22. The leaves reappear in the shadowy part of the tapestry that covers the table in the lower left foreground of *The Lacemaker* [56]; their presence there is more talismanic than decorative—almost as if they were the signature of the impersonal imaginative force that accomplishes its purposes through the medium of the artist's intentions.

23. The anti-illusionistic black of the artist's hat does, however, retain its associations with maleness. The hole it cuts in the mosaic of the canvas stands in marked contrast to the ontologically enhanced cavity that opens at the heart of female mystery in *Woman Pouring Milk*. Woman's darkness, in Vermeer's meta-

physics, has to do with space, containment, absorption in being; man's with consciousness and its inability to disappear or be assimilated into the fabric of the world at hand. Both these blacks, it will be recalled, play a part in the structure of *Head of a Young Girl*.

24. Bianconi, *The Complete Paintings*, p. 94.

25. The negative shape outlined by the edges of the space between the couple is almost exactly the same in both paintings, and in *Soldier and Young Girl Smiling* as well.

26. Massey, *The Gaping Pig*, pp. 194–95.

27. Harry Berger makes an elaborate case for the ironical intent of *Allegory of the New Testament*, without referring to *Artist in His Studio*: see "Conspicuous Exclusion," pp. 244–52.

28. Vermeer has somehow managed to give us not so much the allegory itself as the setting for it, the "live" tableau from which it is to be copied.

29. The presence of the crucifixion in the background of *Allegory of the New Testament* is comparable to that of the portrait of the upright gentleman in the background of *Couple with a Glass of Wine* (cf. the discussion on p. 48, above). Indeed, *Allegory* seems to mark a return, in refined form, of the sardonic, self-critical attitude that characterizes the earlier painting. the representational virtuosity of the painting as a whole has much the same effect as the still-life of *Couple*: it seems less an indulgence in art-for-art's sake than an act of contempt directed at the bad faith of art itself in this context. The glass sphere may well be a symbol of a promised eternity, but in the closed, leaden atmosphere of the painting, it is more persuasive as a symbol of vanity (as if the two were one and the same here)—and the vanity in this case is not the message of the allegory but a comment on it, and on the sort of painting for which it provides the pretext.

30. Vermeer's choice of objects is for the most part dictated by the descriptions in Ripa's *Iconologia* of "Faith" and "Catholic or universal faith"; the glass sphere is a notable exception.

31. Berger makes this point more elaborately; see "Conspicuous Exclusion," pp. 249–50.

32. Gowing, *Vermeer*, p. 45.

33. Contrast the effect in *Las Meninas* of the hand suspended in mid-air, between the canvas that turns its back on us and the eyes that gaze out of the painting at their absent object, whose place we occupy.

34. Gowing, *Vermeer*, p. 141.

35. Bianconi notes that both the painter's "gala" costume and its immaculate appearance are in striking contrast to the usual way that his contemporaries represented themselves and their surrogates. Other art historians have found the style of his clothing to be deliberately anachronistic, dating back to the fashions of the previous century (for references, see Bianconi, *The Complete Paintings*, p. 94). If they are right, the comic irony of the painter's concern with History and/or Fame is further underscored.

36. Massey, *The Gaping Pig*, p. 92.

EPILOGUE: MEANING IN VERMEER

1. *Artforum* 14 (1975), p. 48.

2. Walsh, "Vermeer," sec. 3.

3. Walsh, "Vermeer," sec. 3.

4. The most influential work in this area is E. de Jongh, *Zinne- en minnebeelden in de schilderkunst van de 17e eeuw* (Amsterdam, 1967). See also the same author's "Grape Symbolism in Paintings of the 16th and 17th Centuries," *Simiolus* 7 (1974), pp. 166–91, and "Pearls of Virtue and Pearls of Vice," *Simiolus* 8 (1975–76), pp. 69–97.

5. Kahr, "Vermeer's *Girl Asleep*: A Moral Emblem," pp. 127, 131.

6. Christopher Brown, *Simiolus* 9 (1977), p. 56; rev. of Blankert, *Johannes Vermeer van Delft*.

7. A. B. de Vries, *Vermeer*, UNESCO Slides "Painting and Sculpture" Series (Paris, 1969), pp. 29, 36.

8. See Luke 10:38–42:

> Now it came to pass, as they went, that he entered into a certain village: and a certain woman named Martha received him into her house.
>
> And she had a sister called Mary, which also sat at Jesus's feet, and heard his word.
>
> But Martha was cumbered about much serving, and came to him, and said, Lord, dost thou not care that my sister hath left me to serve alone? bid her therefore that she help me.

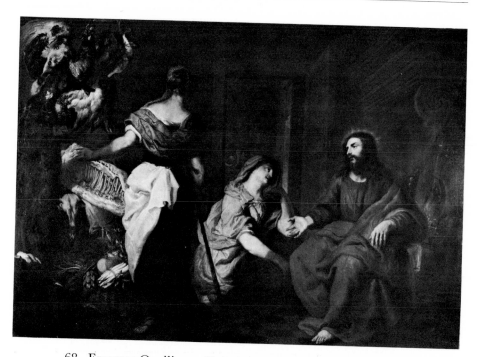

68. Erasmus Quellinus: *Christ in the House of Martha and Mary.*
67¾ × 95¾ in. Musée des Beaux-Arts, Valenciennes

And Jesus answered and said unto her, Martha, Martha, thou art careful and troubled about many things:

But one thing is needful: and Mary hath chosen that good part, which shall not be taken away from her.

9. Compare the version by Erasmus Quellinus the Younger [68], which is almost certainly the chief source of Vermeer's painting. As Gowing points out (*Vermeer*, p. 80), it appears from the similarities in the handling of drapery and in the arrangement of the group of Christ and Mary that Vermeer knew the actual picture. In spite of the more recent work of Blankert, Gowing's still remains the best account of Vermeer's stylistic and iconographic borrowings.

10. Walsh, "Vermeer," sec. 2.

11. Vermeer's uniqueness in this regard can be gathered from the more typical

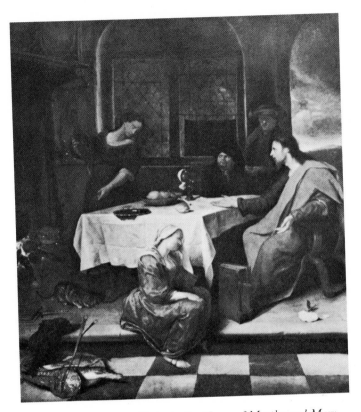

69. Jan Steen (?): *Christ in the House of Martha and Mary.*
41¾ × 35 in. Location unknown

Dutch treatment of the subject in the painting questionably attributed to Jan Steen [69]. The painter here too appears to be working from a direct knowledge of the version by Quellinus (rather than, as Blankert asserts [*Vermeer of Delft*, p. 13], from that of Vermeer; indeed, if there is any direct connection at all between the two paintings, it would appear more likely that Vermeer is the borrower), but he modifies it in the opposite direction—establishing and elaborating on the narrative framework, littering the composition with emblematic objects, and stressing (however clumsily) both the ethical distinction between the two women and the didactic nature of Christ's gesture.

12. Pointed out by Gowing, *Vermeer*, p. 92.

13. It would appear from the similarities between the two works—which would be even more striking had Vermeer adhered to his original conception of the background space of *Girl Asleep at a Table* (see above, p. 156, note 27)—that Vermeer had a direct knowledge of the Maes. However, the pose of the central figure has such a rich iconographical history, and such purely intuitive resonance (parallels have been discovered in Rembrandt's drawings, in Renaissance emblem books, in Gothic miniatures, and in figures of mourning on ancient Greek tombs, as well as in the paintings of Vermeer's contemporaries), that distinctions between sources and analogues, and between direct and indirect sources, become in this instance especially difficult to make.

14. Walsh, "Vermeer," sec. 8.

15. *Inside Out: An Essay in the Psychology and Aesthetic Appeal of Space* (London: Faber, 1947), p. 32.

16. Andrew Forge, "Painting and the Struggle for the Whole Self," p. 48.

17. Walsh, "Vermeer," sec. 8.

18. Hans Koningsberger, *The World of Vermeer, 1632–1675* (New York: Time, Inc., 1967), p. 152.

19. Walsh, "Vermeer," sec. 8.

20. Koningsberger, *The World of Vermeer*, p. 152. In this reading, the jewelbox conveniently becomes a "strongbox."

21. Blankert, *Johannes Vermeer*, p. 64.

22. Walsh, "Vermeer," sec. 8.

23. Arthur K. Wheelock, Jr., *Art Bulletin* 59 (1977), p. 440; rev. of Blankert, *Johannes Vermeer*.

24. Koningsberger is able to acknowledge the affirmative force of the woman's presence, but only by assimilating it to the religious allegory: "And yet despite these allusions to death, the painting is not depressing. Standing there with scale in hand, a focus of calm in a twilight glow, she makes clear Vermeer's intention—the celebration of life everlasting" (*The World of Vermeer*, p. 152). Yet she exists as an embodiment of what is *intrinsically* meaningful in human life, not as an allegorical emblem of what lies beyond it; and she allays the fear of death not with the promise of transcendence but with a feeling for the ripeness of the present moment, an intuitive faith in a purely immanent grace. Her pregnancy ensures the everlastingness of *mortal* life, and I assume that this is not what Koningsberger means by "life everlasting."

70. Pieter de Hooch: *Woman Weighing Gold.*
Staatliche Gemäldegalerie, Berlin-Dahlem

25. Gowing, *Vermeer*, p. 42.
26. As can be judged from De Hooch's treatment of the same subject [70].
27. It is interesting in this regard to compare *Woman Holding a Balance* with *The Geographer* [71] and *The Astronomer* [72], whose gestures are obviously conceived in dialectical relationship to it. The male figures reach out through consciousness in an attempt to map, to encompass the limits of their world, to grasp it in the form of a thought, an image (yet in doing so they instinctively tighten their grasp on the material reality that silently lends support to their speculations); the woman locates, more intuitively, the center, the balance point, and (lost in thought) gently touches down into it. The difference charted here represents the outcome

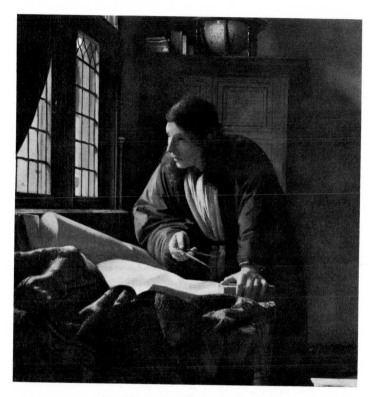

71. Vermeer: *The Geographer*.
20⅞ × 18¼ in. Städelsches Kunstinstitut, Frankfurt

of the theme first broached by Vermeer in the image of the asymmetrical fit between the man and woman of *The Procuress*, and in the triangularity of map, soldier, and smiling girl that structures *Soldier and Young Girl Smiling*. But by this point in his development, his dialectic of male and female ontologies has evolved into an intimate, wholly nonjudgmental complementarity. Either gesture—that of *Woman Holding a Balance*, or the one adumbrated by *The Geographer* and *The Astronomer*—might serve as an emblem of the activity of the artist depicted in *Artist in His Studio*. Only by taking the two together can we adequately suggest the nature of what is being accomplished, and the needs that are being fulfilled, within the scene of that painting. The same is true of the androgynous purposes of Vermeer's own art.

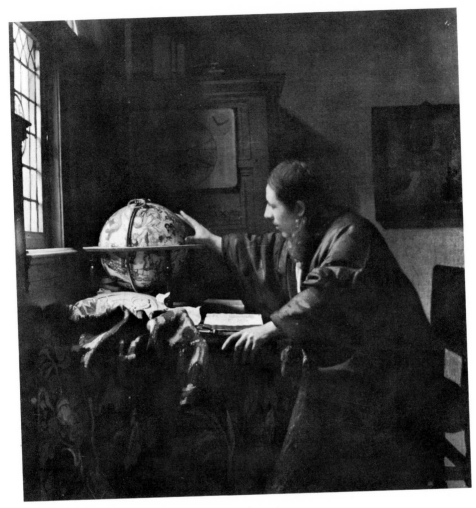

72. Vermeer: *The Astronomer.*
19¾ × 17¾ in. Private Collection, Paris

ACKNOWLEDGMENTS

Couple Standing at a Virginal is reproduced by Gracious Permission of Her Majesty the Queen. I would like to thank the following for providing photographs and information: National Gallery of Art, London; Sir Alfred Beit; National Gallery of Scotland, Edinburgh; Tom Scott (Plates 27, 47); National Gallery of Ireland, Dublin; Mauritshuis, The Hague; Rijksmuseum, Amsterdam; Service de Documentation Photographique de la Réunion des Musées Nationaux (Plate 12); Caisse Nationale des Monuments Historiques (Plates 9, 56, 72 © Arch. Phot. Paris/s.p.a.d.e.m.); Musée de Louvre, Paris; Bibliothèque d'Art et d'Archéologie, Fondation Jacques Doucet; Musée des Beaux Arts, Valenciennes; Photo. Giraudon (Plate 68); Museo del Prado, Madrid; Kunsthistorisches Museum, Vienna; Photo Meyer, K. G. (Plates 41–45); Staatliche Gemäldegalierie, Berlin-Dahlem; Staatliche Gemäldegalerie, Dresden; Gerhard Reinhold, Leipzig-Mölkau (Plates 15, 25, 29–31, 53); Herzog Anton-Ulrich Museum, Brunswick; Städelsches Kunstinstitut, Frankfurt; Bode Museum, East Berlin; Art Institute, Chicago; Hill-stead Museum, Farmington, Connecticut; Isabella Stewart Gardner Museum, Boston; Museum of Fine Arts, Boston; Metropolitan Museum of Art, New York; The Frick Collection, New York; National Gallery of Art, Washington. I would also like to thank Catherine Baetjer of the European Paintings Collection of the Metropolitan Museum of Art for permission to reproduce the radiograph of *Girl Asleep at a Table*, and the National Endowment for the Arts for a fellowship that allowed me to see several of Vermeer's paintings for the first time. Above all, I would like to express my gratitude to William McClung, without whose patience and continued support this project would have long since been abandoned.

INDEX

Paintings by Vermeer are listed individually; page numbers in italics refer to illustrations.

Designer:	Wolfgang Lederer
Compositor:	Dharma Press
Separations:	Color Tech Corporation
Printer:	Southeastern Printing Company
Binder:	Riverside Book Bindery
Text:	Fototronic Baskerville
Display:	Fototronic Baskerville
Cloth:	Holliston Roxite B 53590
Paper:	70 lb. Sterling Dull